LONDONTOWN

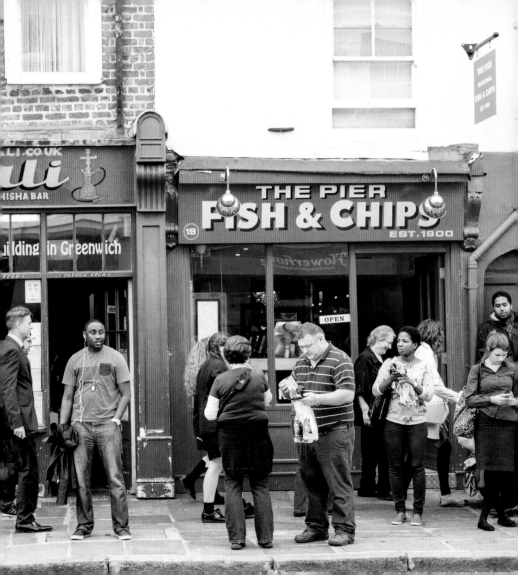

LONDONTOWN

A Photographic Tour of the City's Delights

By Susannah Conway
Foreword by Helen Storey MBE

CHRONICLE BOOKS
SAN FRANCISCO

CONTENTS

FOREWORD

I am a Kodak kid of the 1960s. My memories of growing up in London are washed with a warm orange and a soft grey—it's hard to know if those are the neural shades of memory itself, of the London light back then, or simply the nature of film, its processing, and the seven-day wait until the chemist returned the eagerly awaited evidence of our intimately witnessed lives.

We lived in Belsize Park. Twiggy, perhaps the world's first supermodel, lived nearby on the Crescent, as did the playboy of the '60s fashion photography world, David Bailey. Somehow, those that made their living taking creative risks—the poets, the writers, composers, actors, the film makers, the cartoonists—all gravitated to our small city village, a heart-held community I will always call home.

Over the years, the jazz-coloured London I grew up in has only become more vibrant. It's possible to experience so many other parts of the world, simply by walking this city's streets. London is, and was, a place that can fertilise

dreams. It may have been a combination of the slow-looking-up toward adults who seemed so alive with energy and the feeling that the exotic was normal that shaped the creative life I went on to live.

Different parts of the city carry memories of my own journey—finding a way to know who I am, what kind of a woman I would go on to become, and where the edges of what I am capable of lie. Educated in the north west (a rough and dysfunctional comprehensive education), I lived for a while in the west (near a flyover to Heathrow Airport) and produced my first fashion collections in the East End (Brick Lane and Dalston).

As much as the place, it is the people who make up London. And so, of course, it's not just where you are, but whom you encounter. A Londoner isn't someone who was simply born and bred here, or someone who just visited a while and stayed. As in other major cities, the speed of life—and therefore how

people experience time here—is particular. Thus, a Londoner is someone who lives on London time.

Some feel they have to leave the city to find peace. I don't. You simply need to know where to go; then it becomes possible to find yourself amid nothing but birdsong, or to feel the collective anonymity in a throng of a *Blade Runner* night.

In this book, you soon realize that Susannah's eyes naturally notice what a Londoner's would, past the postcards and into the detail of a living London. Flowers, people, sky, architecture, tattooed walls, Amy Winehouse as a Union Jacked angel, sun through a jar of honey, food of every kind, markets, canals, and the river—somehow she has caught the various movements of our lives from pram to grave.

She shows us time in flow, between now and way back then, from the ancient green of Hampstead Heath to the 1950s concrete of South Bank, from Nelson Mandela in bronze to the man reading his book on the pavement.

Shopping is carried, hands are held, and a future London is hinted at too, in the making and continued building of the city itself.

To see London through Susannah's lens—covering north, south, east, west, and the centre—unexpectedly brings all the other senses into play. Sound, scent, and a tactility of place and people are suggested—sensory impressions that are normally hard to imagine at a distance.

But this is also a book about light of a particular kind. And while London can be known for its rain, there are no images of the town against that backdrop. I wonder if this reveals something of Susannah herself—an intuitive aspiration on behalf of any population-busting city right now. For this is "us" in authentic relationship to our surroundings, the way we occupy space. Again I find myself wondering about that light. Is it the nature of the city, of memory, of photography? Or is Susannah's light perhaps an unconscious reminder to us from her, that sunlight falls the same on us all?

Helen Storey MBE, February 2015

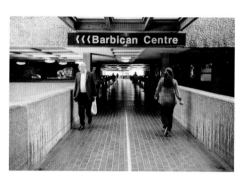

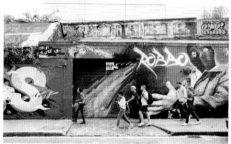

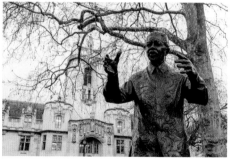

Queen's Park Farmers' Market, Salusbury Primary
 School, Salusbury Road, NW6 6RR
 www.lfm.org.uk/markets/queens-park
 (⊖ Queen's Park)

Sclater Street, London E1 (⊖ Shoreditch High Street)

The Barbican, Silk Street, EC2Y 8DS
 www.barbican.org.uk (⊖ Barbican)

Statue of Nelson Mandela, Parliament Square, SW14
 (⊖ Westminster)

INTRODUCTION

"London perpetually attracts, stimulates, gives me a play and a story and a poem, without any trouble, save that of moving my legs through the streets. . . To walk alone through London is the greatest rest." —VIRGINIA WOOLF

I have the very good fortune to live in London, one of the most historic, innovative, and unfailingly maddening cities in the world. Living alongside eight million other people is not without its challenges, yet I honestly can't think of anywhere else I'd rather live.

By no means the biggest city geographically nor the most densely populated, London mixes grandeur and history with commerce and multiculturalism like it's been doing it for centuries—which, of course, it has. There are so many layers to this city it would be impossible to experience it all in a week, a year, or even a lifetime. I love that there's always something new to discover when I step out the door into Londontown—that's the name I've always called her. *London Town* might be the name of a McCartney album, but to my mind it's *Londontown* said with a wink and a faux-cockney accent. This beautiful city is so vast it holds the story of every soul who's ever walked along the banks of the Thames. From Roman times to the twenty-first century, this is the place where laws are made and hearts are broken. Living here can feel like being in the centre of the universe, all played out to the faint rumble of the Underground, the pulse of our dear old Londontown.

I like to think of myself as a Londoner-by-default because my parents were working in London's New Scotland Yard when they met—my mother was a secretary and my father a policeman—but the truth is I was born in Surrey and grew up on the south coast of England. I didn't stake my claim on a piece of the city until I first moved here in 1995. I spent a decade building a career and life that suited me back then, a life that fell apart after a devastating bereavement in 2005. No longer able to function in the city, I moved back home

to heal beside the sea. As the years passed, and I worked through my loss, I found myself feeling a familiar pull back to London. In October 2012, after nearly eight years of healing my heart and uncovering my true path, I finally returned to the city—and we've been having a torrid love affair ever since.

As a blogger living in London, I frequently get emails from readers who've booked their flights and want to know where to go. "Tell me the places where the locals hang out," they write, and I know exactly what they're after. People are hungry to experience the city in an authentic way—to sample the coolness of the place, the edgy and unexpected. London is so much more than Big Ben and Buckingham Palace, and luckily you only have to ride the tube for half an hour to find this out for yourself.

Photographing this book has cemented my deep love and affection for this city. As

I planned my shooting itinerary, my number one question was always: "*Where* would be fun to photograph?" London provides an embarrassment of riches, photographically speaking, with iconic sights around practically every corner. I wanted to create a portrait of London that included some recognisable landmarks—because London wouldn't be London without them—but also featured the neighbourhoods I tell friends to explore when they visit from out of town. In a city of thirty-two boroughs, it was necessary to narrow my explorations down to a few key areas in each of the five main districts (determined, loosely, by postal code): north, south, east, west, and central. There's a list of street names on pages 218–223 for every photograph in the book so you can plan your own urban safari—just remember to wear comfortable shoes. London is definitely best explored on foot.

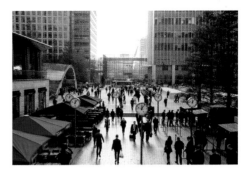

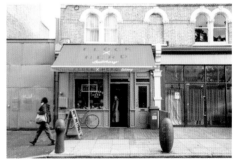

There are lots of people in this book because *there are lots of people in this city*: the locals, the visitors, the passersby, the passers-through. It would be unthinkable to photograph a book about London without including the people. And even though riding the tube at rush hour is my least favourite thing to do, I have a soft spot for my fellow Londoners. They are full of heart and humour, even when they're moaning about people "standing on the wrong side" of tube station escalators. Some of the most entertaining conversations I've ever had were with true-blue London cabbies.

Everyone has their own unique experience of London—their own stories and memories, favourite haunts and memorable walks. I truly hope this book inspires you to get your camera out and explore Londontown for yourself. There's a new memory to be made around every corner.

Reuters Plaza, E14 (⊖ Canary Wharf)

Flock & Herd, 155 Bellenden Road, SE15 4DH
www.flockandherd.com (⊖ Peckham Rye)

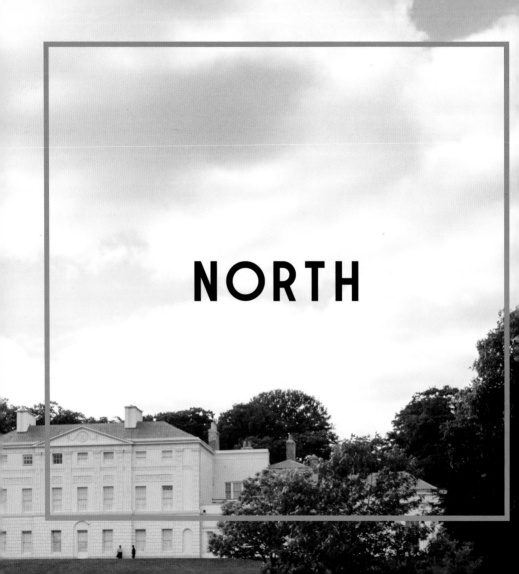

NORTH

eafy north London boasts some of the loveliest green spaces in the city, including beautifully bucolic Hampstead Heath—it's like a precious slice of countryside within the city walls. Pack a picnic and be sure to explore the three public swimming ponds, the grandeur of Kenwood House, and the spectacular view from atop Parliament Hill. It's perfectly possible to get lost on The Heath, which is all part of its charm.

Find your way back to Hampstead High Street to buy vintage books, coffee, and crêpes, then take a five-minute bus ride straight into the heart of Camden Market. The many markets dotted along the high street all bleed together into a lively mass of street food, club-wear, and all the joss sticks you'll ever need. The infamous Stables Market is not unlike the souk in Marrakech, with cobbled pathways winding through more than seven hundred stalls—brace yourself for the weekend crowds, which provide excellent people-watching opportunities.

Camden Lock sits roughly at the centre of Regent's Canal, the stretch of waterway running from Limehouse Basin in the east across to Paddington in the west. Follow the towpath as it snakes past the backwaters of Primrose Hill, down past the zoo in Regent's Park, and along the residential moorings in Little Venice. If you're flagging, there's always the waterbus for the journey back.

Urbanite-friendly Islington has enough restaurants and bars along Upper Street to keep you entertained for days. For antiques, retro clothing, and a slew of collectibles, head to the five markets lining Camden Passage. Enjoy a Full Monty and a flat white at The Breakfast Club before bantering the afternoon away with the knowledgeable market traders.

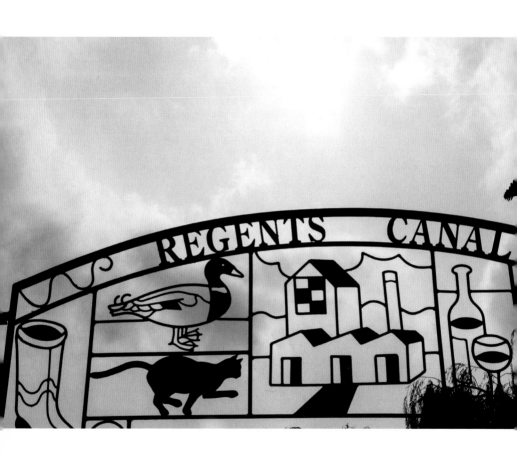

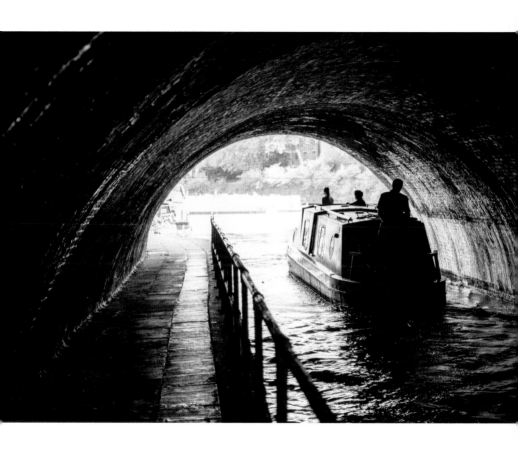

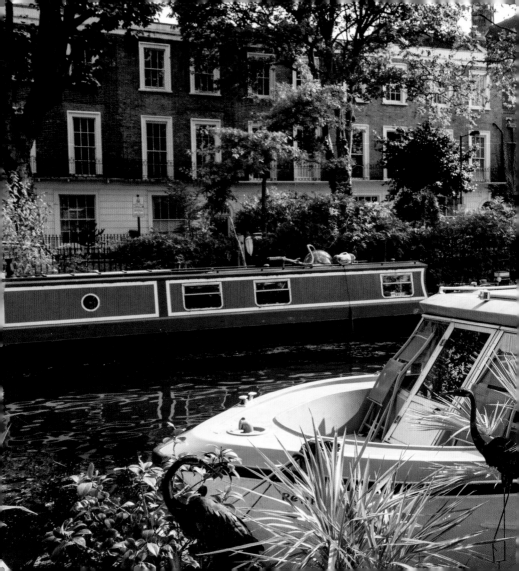

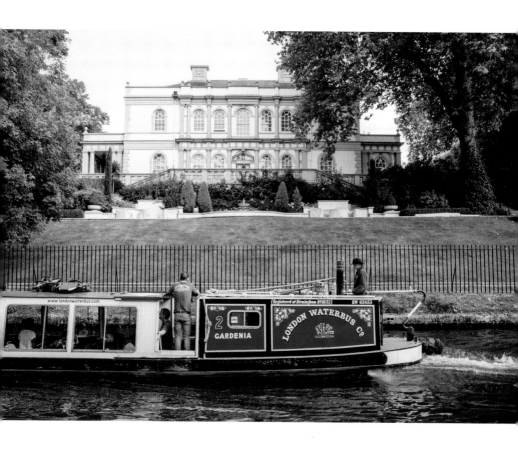

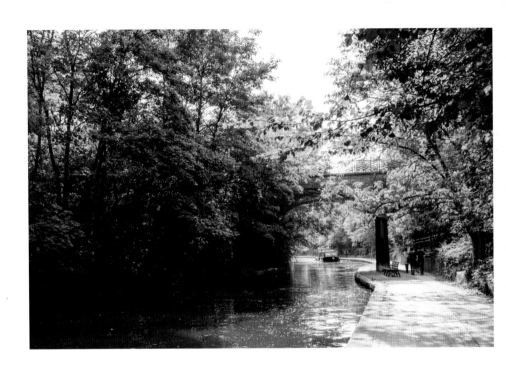

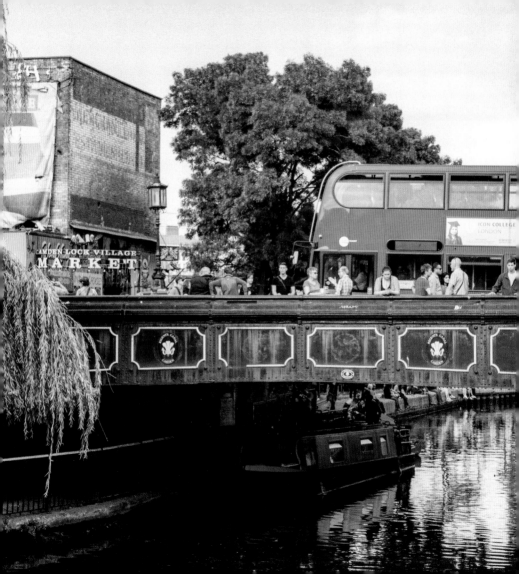

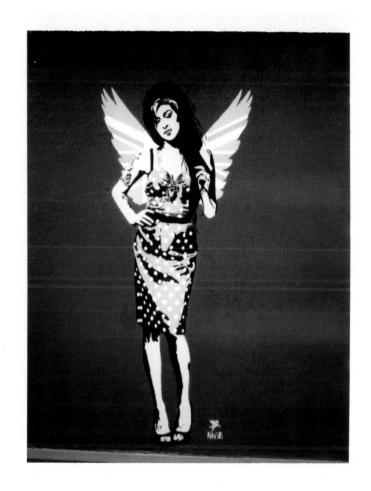

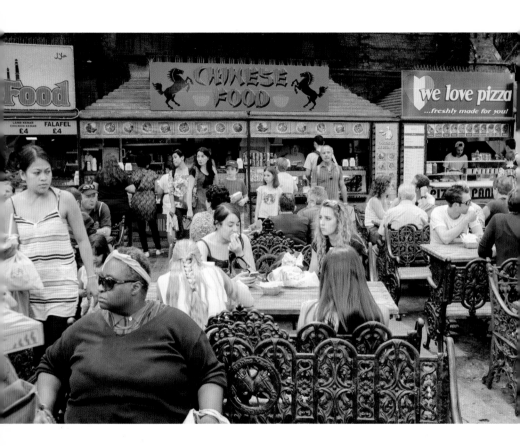

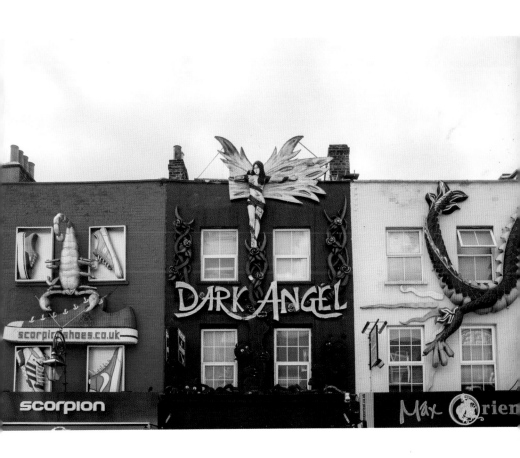

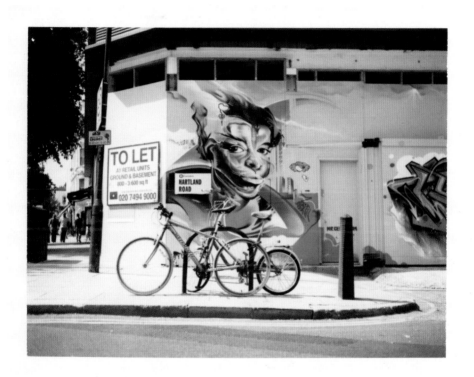

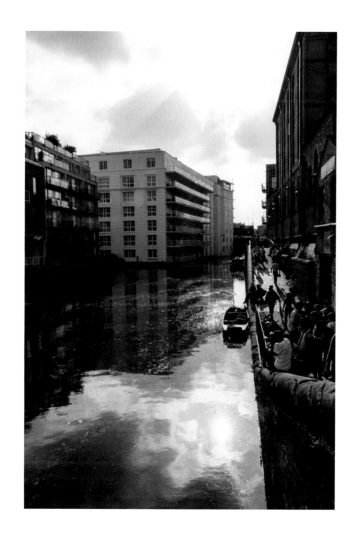

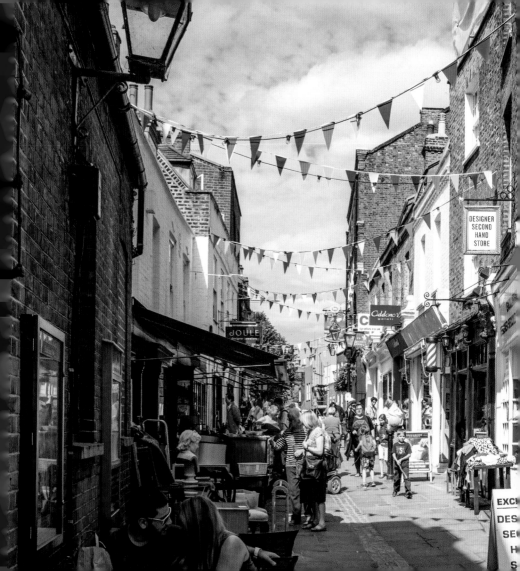

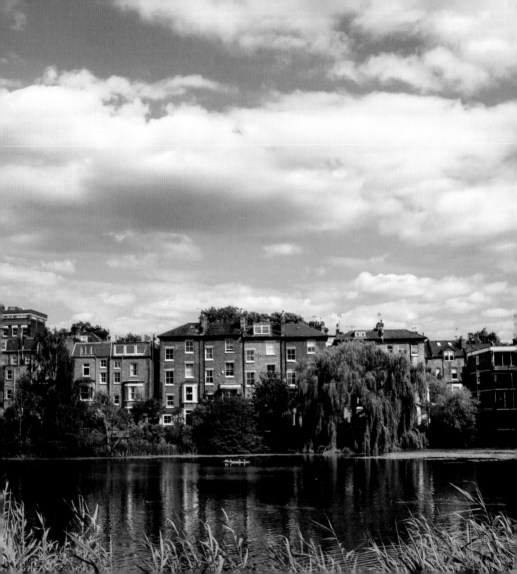

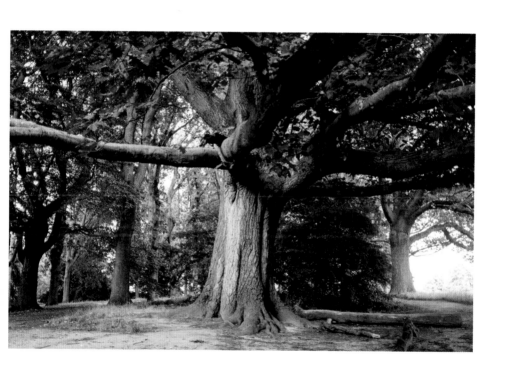

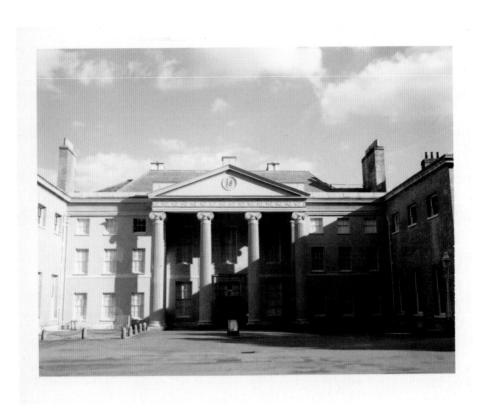

41

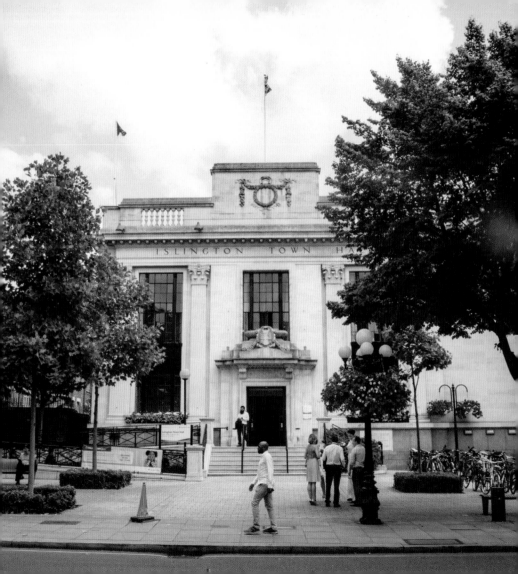

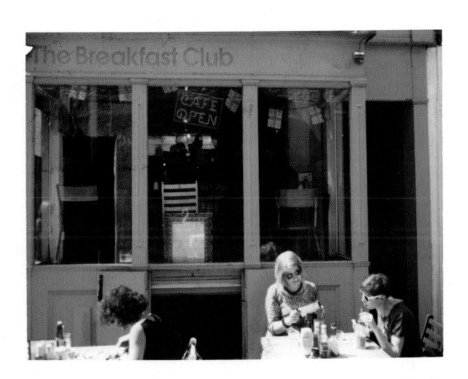

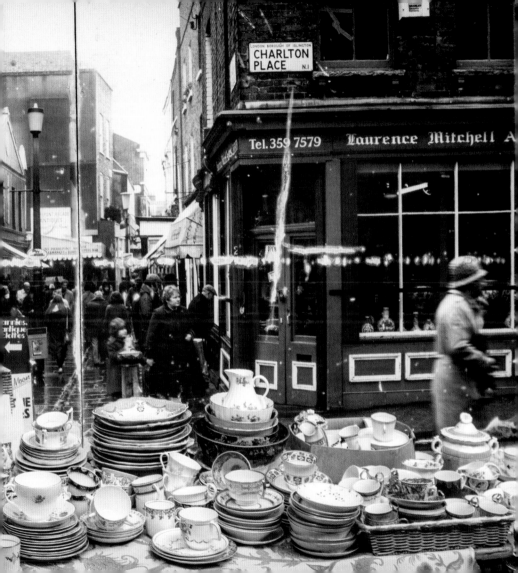

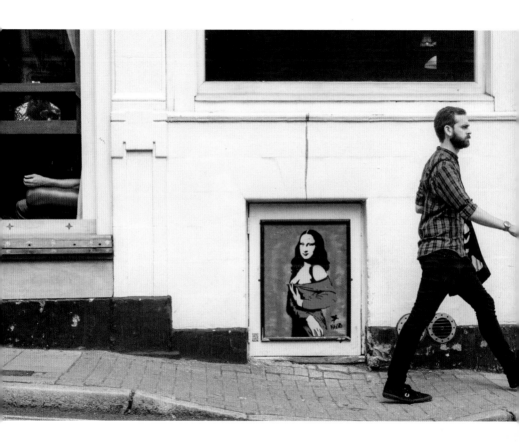

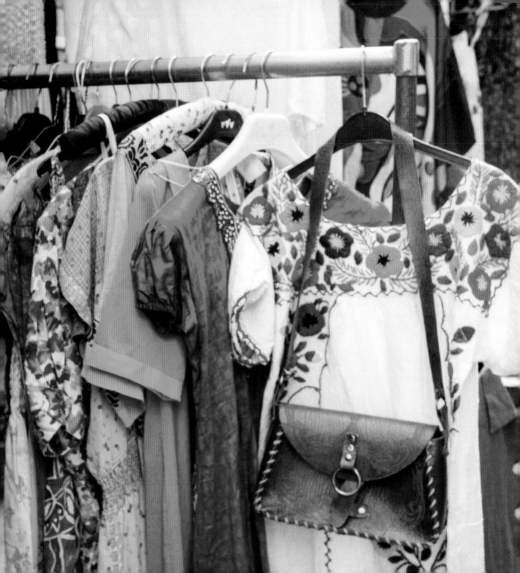

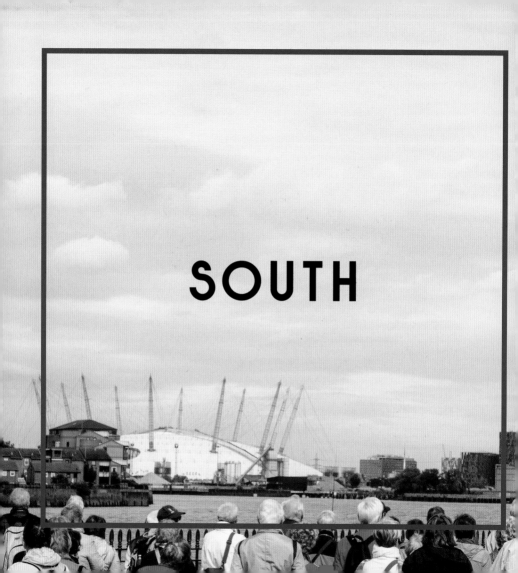

SOUTH

South Londoners are loyal to their side of the river. With fewer transportation links than the rest of the city, this area has a strong sense of community woven through its core. Nowhere is this felt more tangibly than in Peckham. Outside the award-winning library you'll find the Peckham Peace Wall, a permanent artwork celebrating the four thousand notes of support that amassed following rioting in 2011. Nearby Rye Lane is home to the Bussey Building arts centre and plenty of African grocers, while parallel Bellenden Road has morphed into a fashionable "village" boasting trendy eateries, bookshops, and vintage stores. The two sides of Peckham co-exist quite happily.

Brixton sits at the end of the Victoria Line, making it a key transport hub for residents south of the river. Head straight to the bustling street market for clothes, records, and plenty of jerk chicken, then peruse the boutiques and restaurants that have transformed Brixton Village into a foodie's paradise. Catch a matinee at the much-loved Ritzy cinema, then jump on a bus along Brixton Hill to visit the two-hundred-year-old windmill that locals campaigned to restore.

East Dulwich wins my personal prize for Friendliest People in London. Lovely shops, plenty of organic veggies and good coffee, helpful smiley locals, and the Horniman Museum, hands-down the quirkiest museum in the city. The gardens are popular with local families while the museum delights young and old with its eclectic mix of anthropological artefacts.

Greenwich locals love their neighbourhood—a World Heritage Site—and it's extremely popular with visitors, too, as evidenced by the queue of people waiting to stand on the Prime Meridian at the Royal Observatory. Add in the National Maritime Museum, the Cutty Sark, and the grandeur of the Old Royal Naval College, and you have centuries' worth of history waiting to be explored.

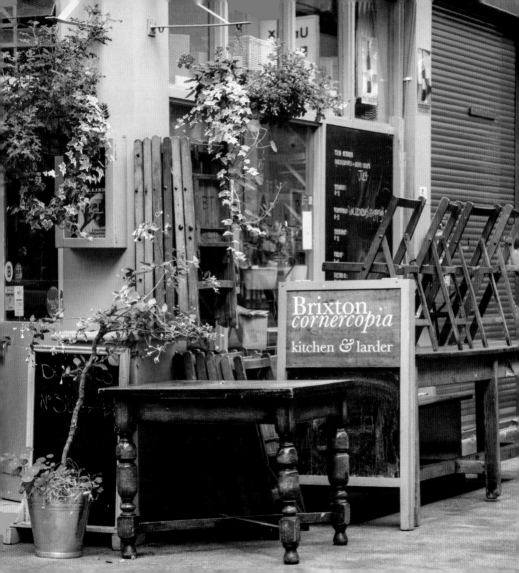

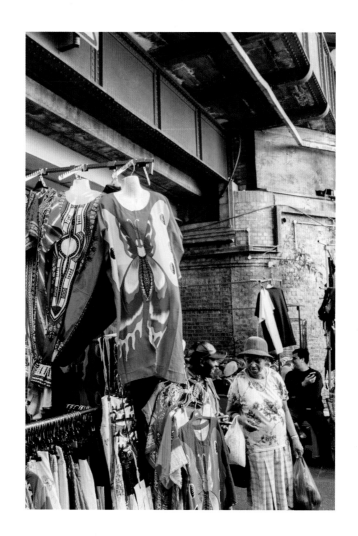

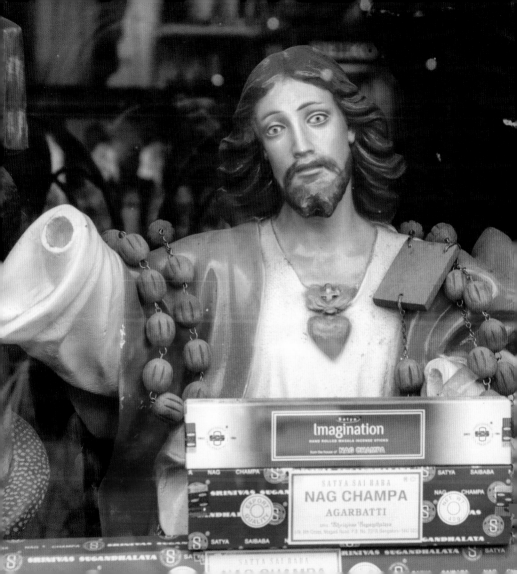

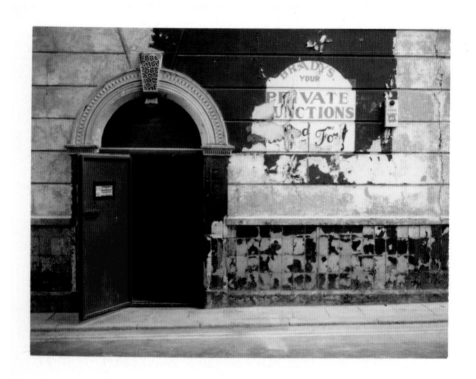

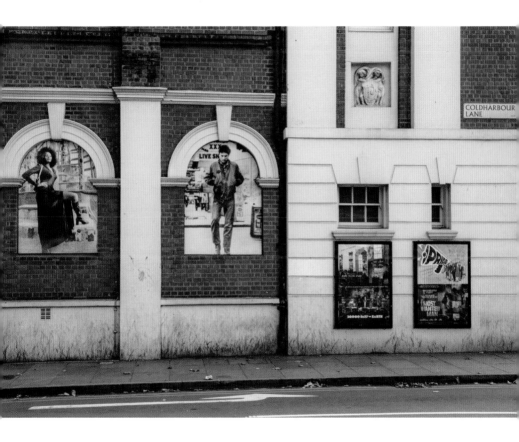

61

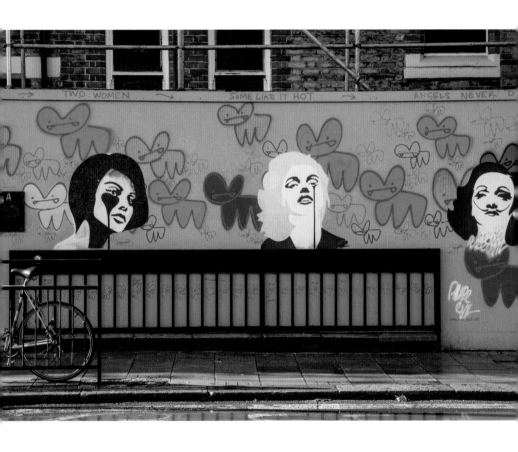

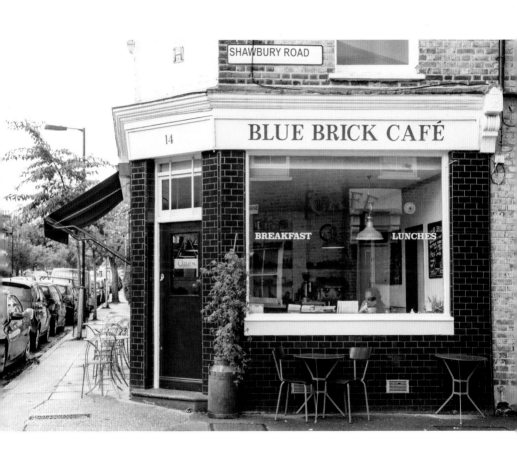

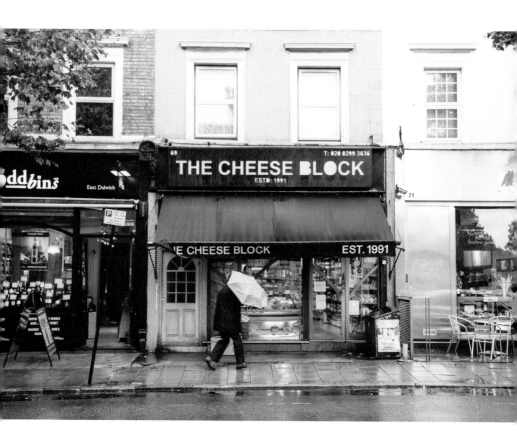

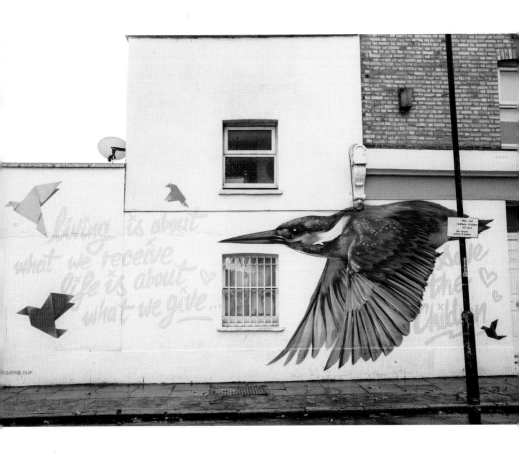

living is about
what we receive
life is about
what we give...

65

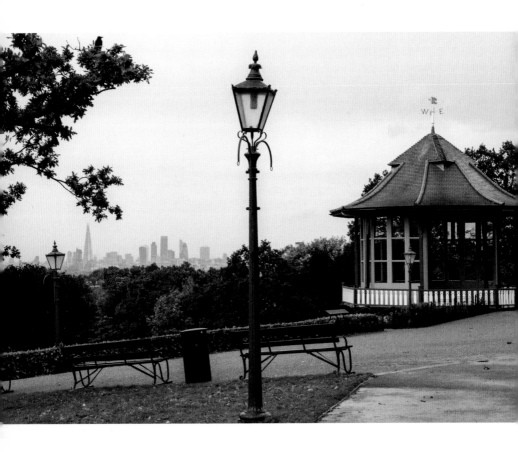

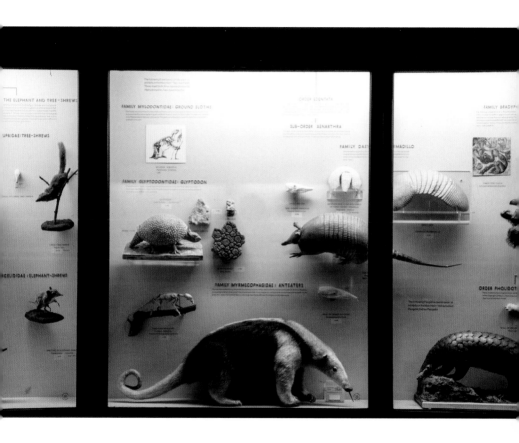

THE ELEPHANT AND TREE-SHREWS

UPAIDAE: TREE-SHREWS

NGELIDIDAE: ELEPHANT-SHREWS

FAMILY MYLODONTIDAE: GROUND SLOTHS

FAMILY GLYPTODONTIDAE: GLYPTODON

FAMILY MYRMECOPHAGIDAE: ANTEATERS

ORDER EDENTATA

SUB-ORDER XENARTHRA

FAMILY DASY

RMADILLO

FAMILY BRADYP

ORDER PHOLIDOT

69

when I die I want to go to heaven unless Margaret Thatcher's there, then I want to go to Peckham	Burger King half price open & you're barred!		TODAY WAS NOT A GOOD DAY	LOOK AFTER PECKHAM AND Look After EACH OTHER. WE ARE ALL RESPNSIBLE FOR OUR OWN UNITY		stop dishou our home	BIG UP PECKHAM ♥	THE CAPITISTS ARE RESPONS.6 PECKHAM SHANE
...peace & love in Peckham!	LONDON ROLLERGIRLS ♥'s PECKHAM	We love Peckham	Love ♥ Peckham from PARIS	Eventhough you might not know anyone in this world CAN'T YOU FIND A LITTLE bit of A DECENT HEART	I LOVE PECKHAM x x x		LOVE ONE ANOTHER	Love Nam ♥
Peckham ★ friendly like it Lysa <!!! ★		born & raised, Peckham to the grave.	LOVE THY NEIGHBOUR AS THYSELF	友情 FRIENDSHIP	XOX	HOME SWEET HOME MR PCE		Peckha
I LOVE PECKHAM JOY OF ETHNICITY	Why did they do Peckham like this xxx	Home	SPEAK 2 THE CHILDREN!!	LOCAL COMMUNITY SOLIDARITY	No Regrets —DAN	MAKE PECKAM SAFE	Peckham is D Best!!	We love Peckham
We Love Peckham ♥	love is the key		I ♥ Peckham		I LOVE PECKHAM	STOP POLICO VIOLENTE	I LOVE Peckham Look it: KAI	IM HER TO MAK DIFFER6 I ♥ P
PEACE! O	lets all live in Peace with... God bless!		Peckham is my Home I Love Peckham xxx	ALL WE Need is LOVE	PECKHAM SO SASSY!	NO AGGRO PEACE	Pe... Pariz Lijah	SE IS LOVE LOVE

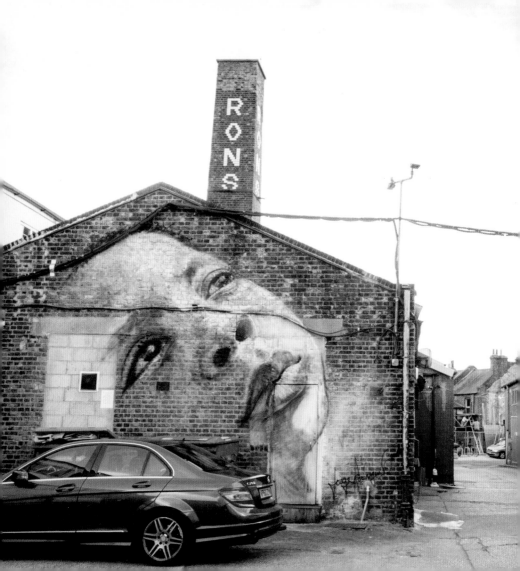

73

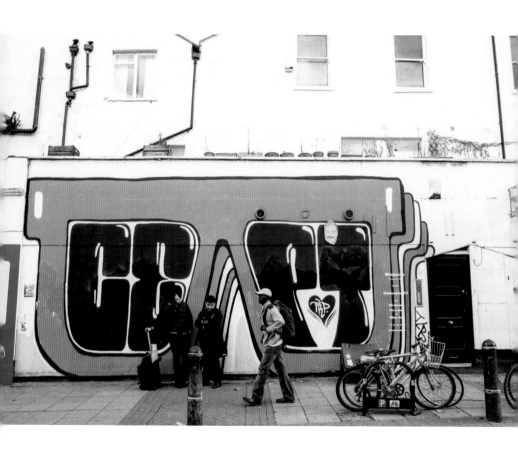

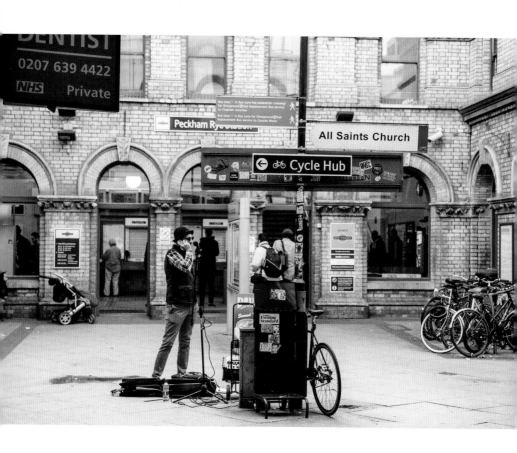

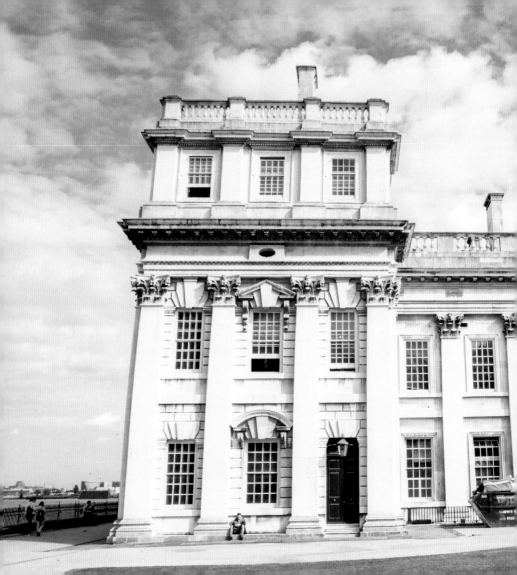

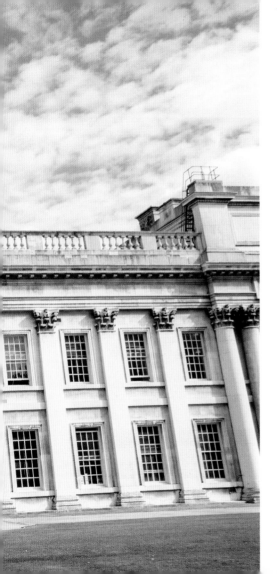

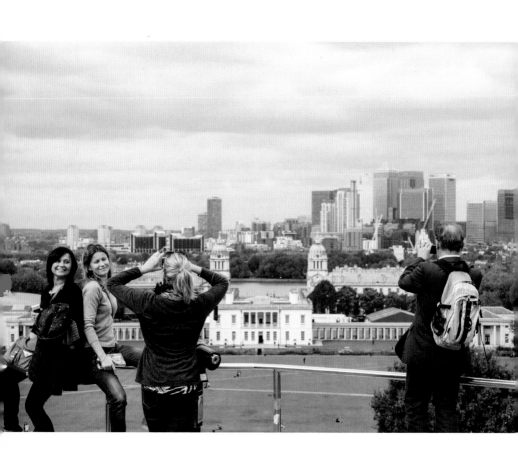

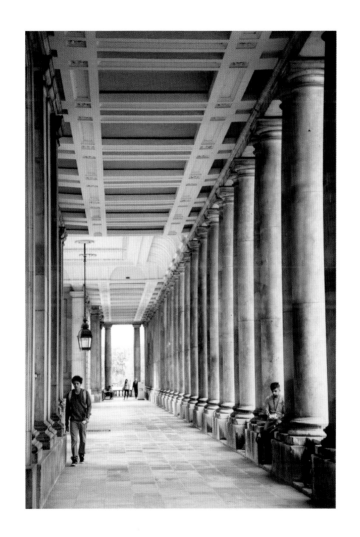

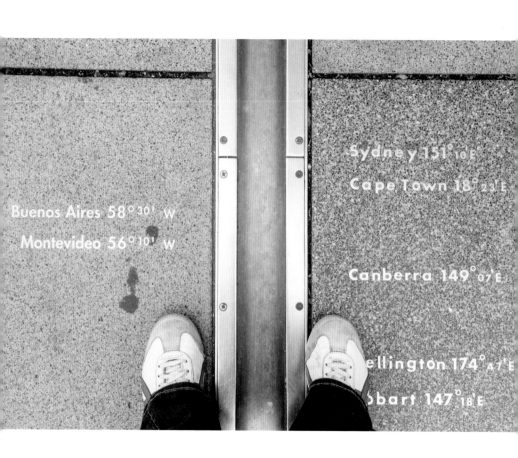

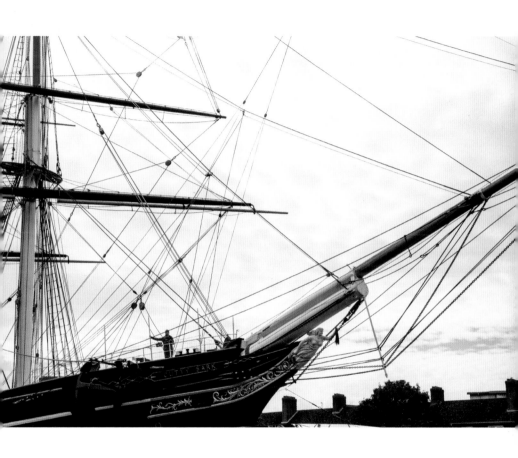

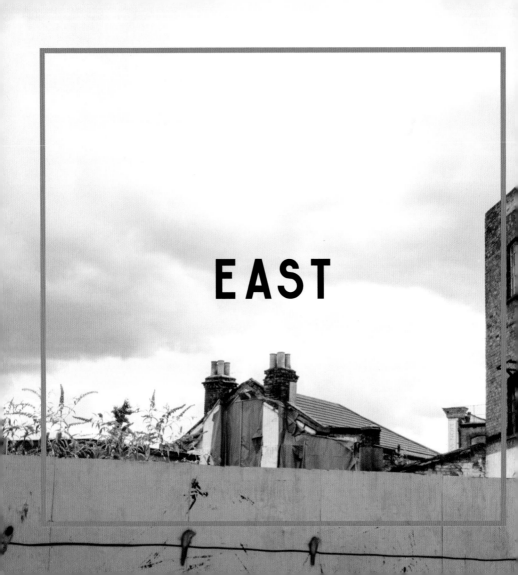

EAST

For a master class in London cool, head straight to Shoreditch and do not pass "go." Firmly established as the heart of hipsterland, independent stores and coffee shops rub shoulders with London's booming tech scene. Pop-up bars, tattoo parlours and a rooftop cinema keep the area buzzing while the buildings themselves wear some of the most exciting street art in Europe—book a guided tour to see the best.

Get up early on Sunday to score armfuls of flowers and a latte at the Columbia Road flower market before slipping away at lunchtime to nearby Brick Lane. Offering every type of food imaginable, it's still hard to beat a hot salt beef bagel from the Beigel Bake, open 24 hours a day, seven days a week. The weekend market is fun if you don't mind crowds, but visiting on a weekday gives you space to admire the ever-changing street art.

Hackney Wick is still rough enough around the edges to attract a dynamic community of creatives. The annual Hackney Wicked art festival hosts exhibitions, open studios, performances, and workshops—the Wick is said to have the highest number of artists' studios in the world. Chatsworth Road market is a Sunday favourite with locals and if you're in need of a coffee, a desk, and a haircut, you can get all three at Hatch, right by Homerton station.

Towering Canary Wharf is starting to resemble a micro–downtown Manhattan. Home to the European headquarters of numerous major banks and media organisations, the area is situated on the regenerated West India Docks, where the waterways and skyscraping buildings make a delightfully photogenic combination. Peek out the window of the automated Docklands Light Railway to get a bird's-eye view before heading across the water to Greenwich.

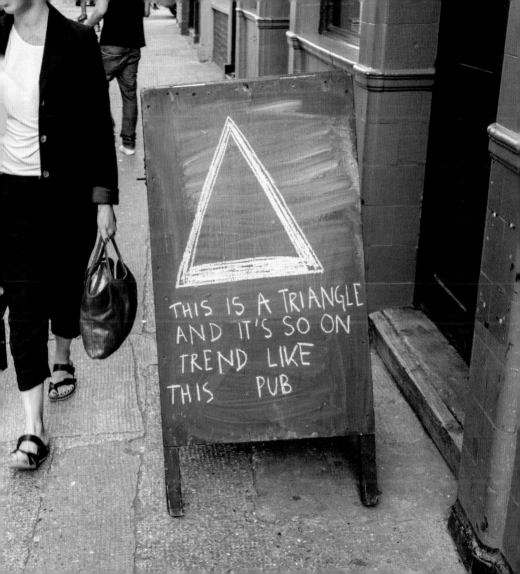

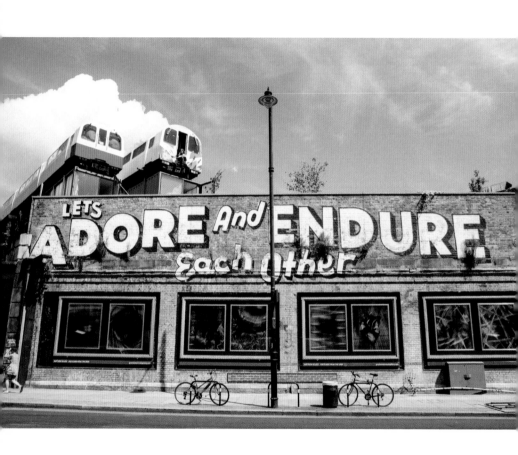

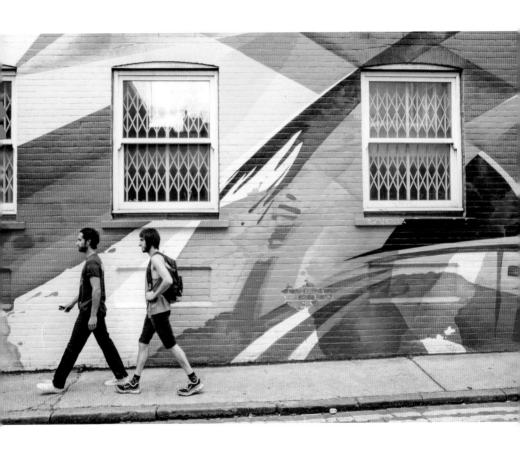

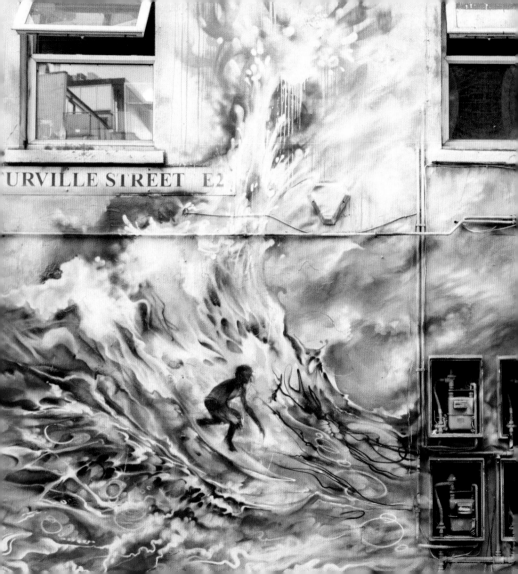

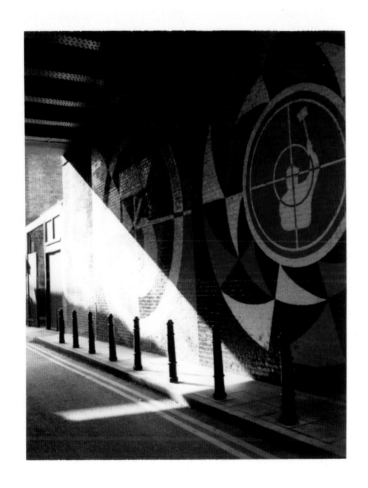

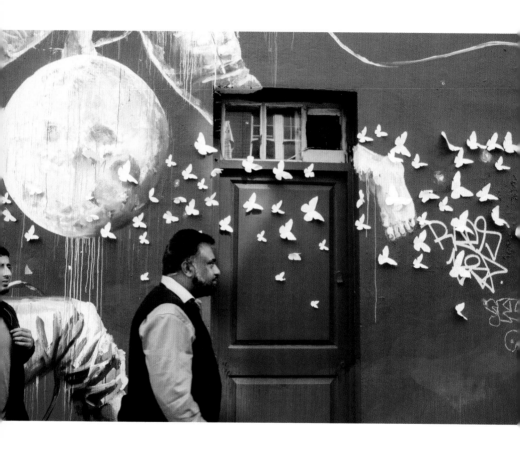

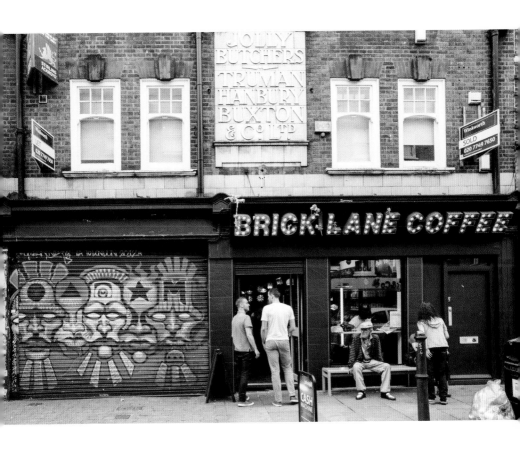

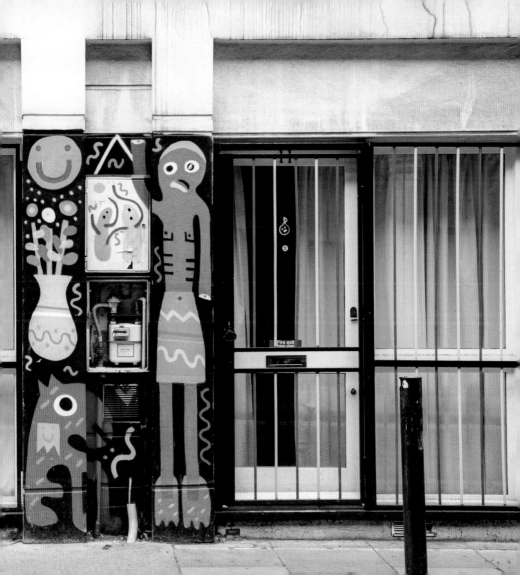

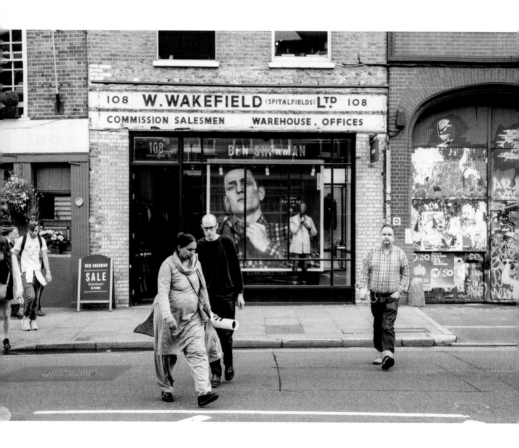

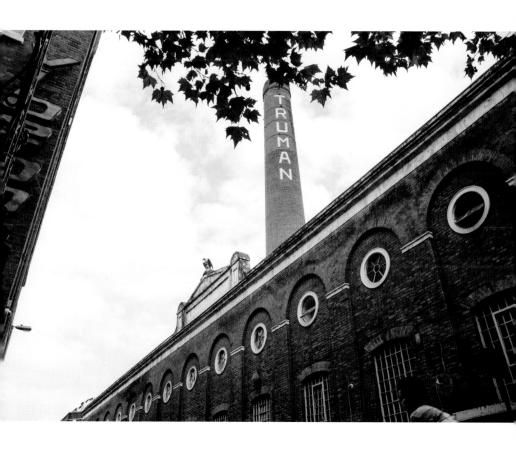

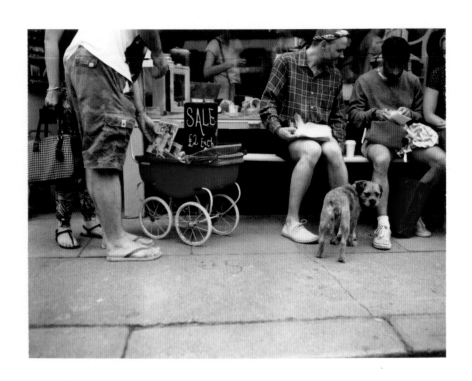

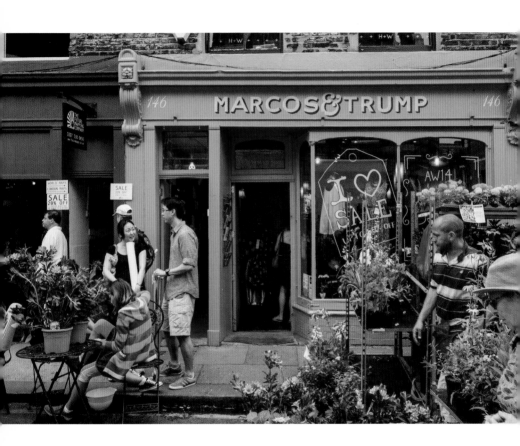

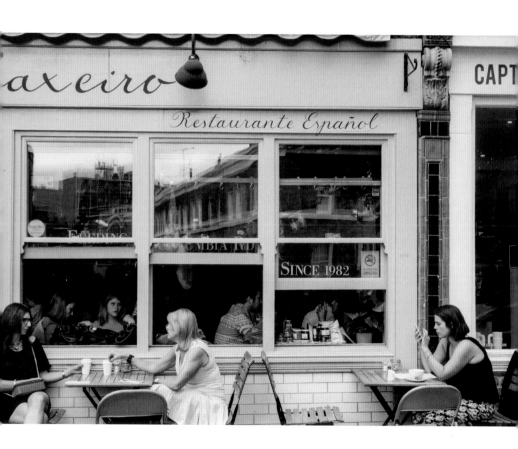

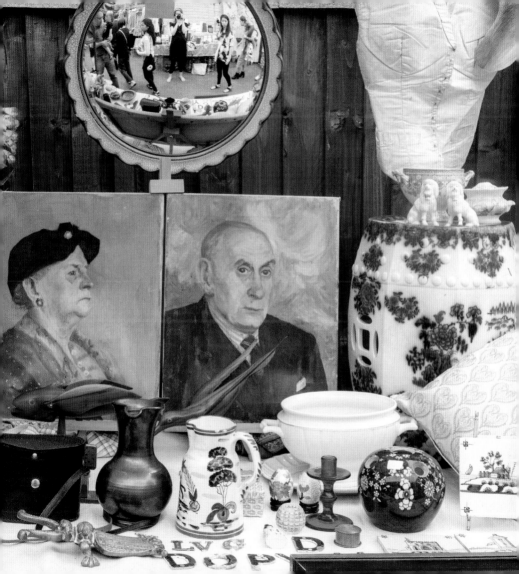

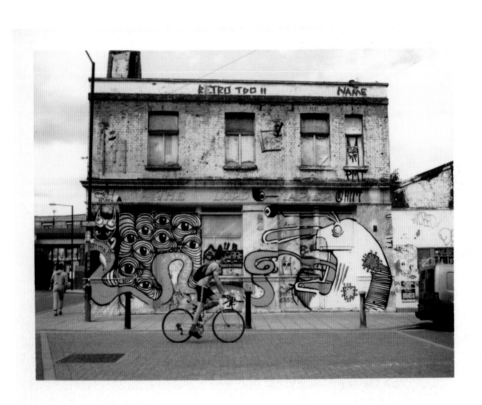

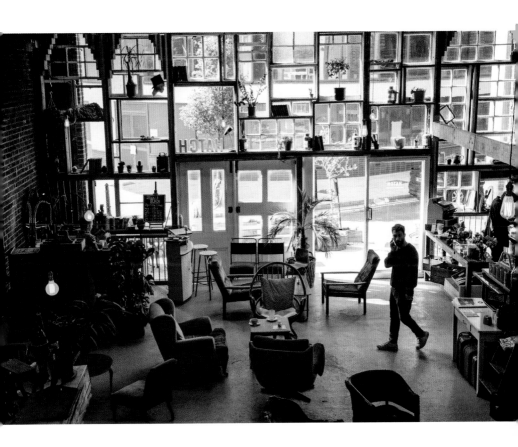

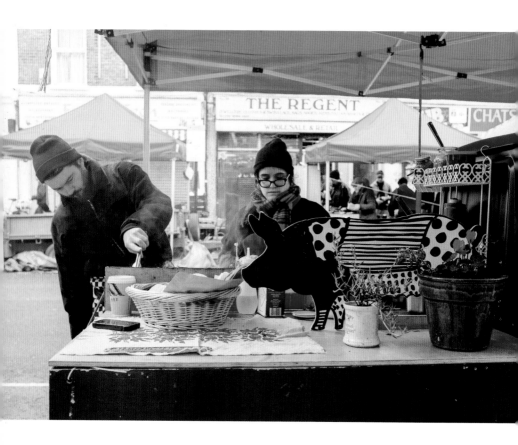

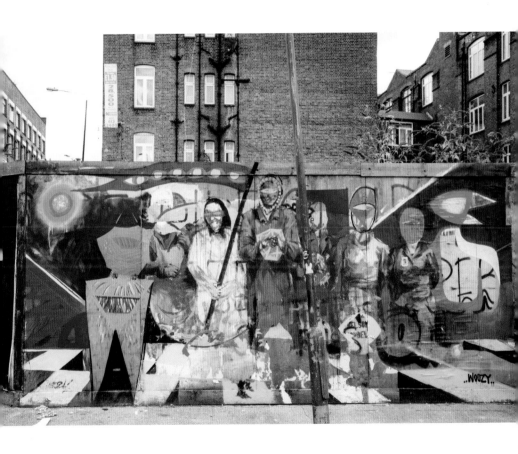

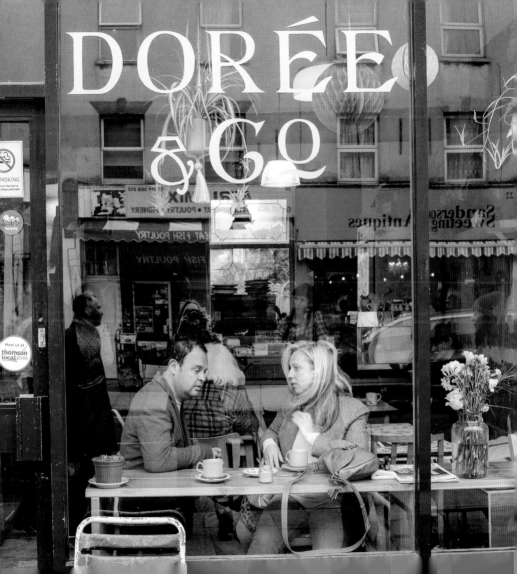

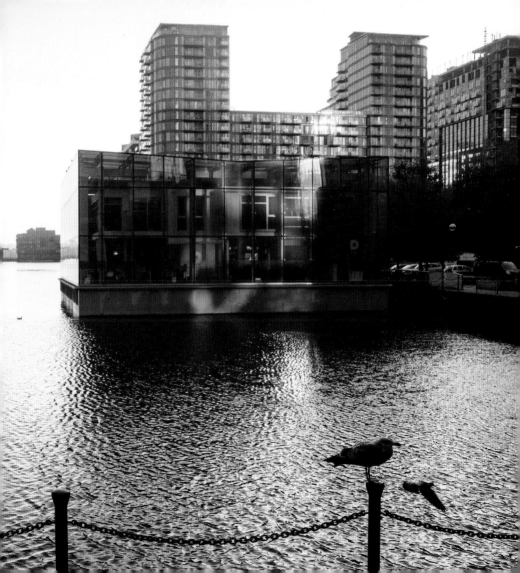

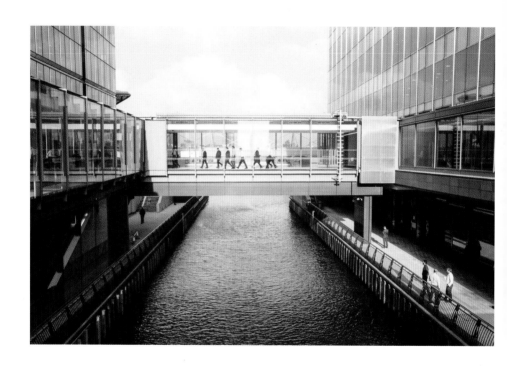

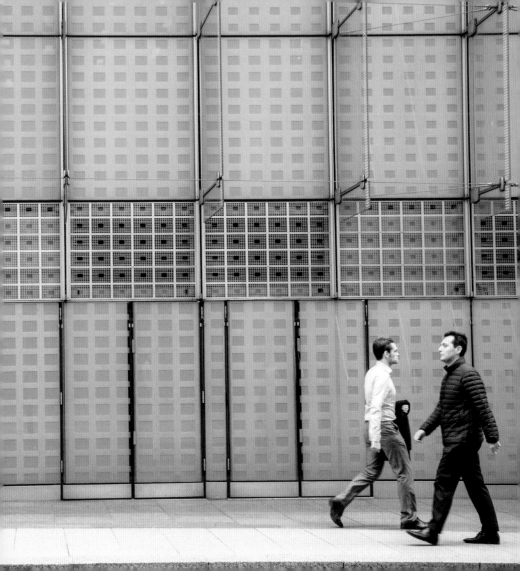

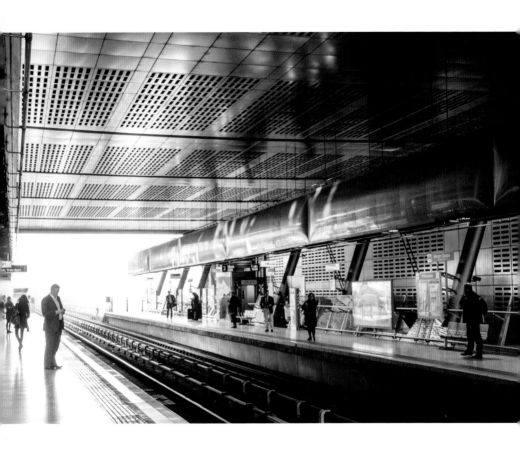

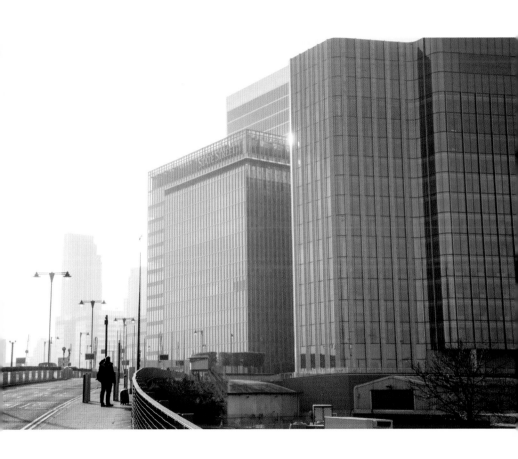

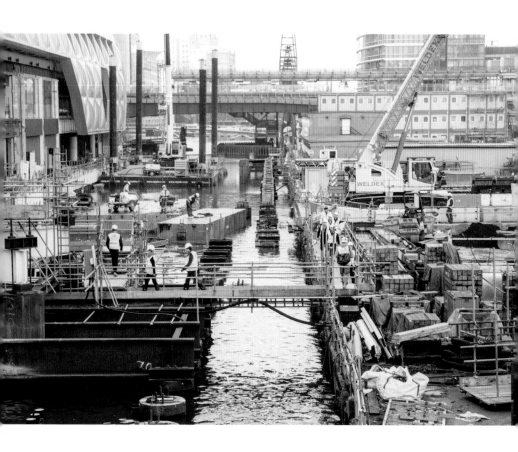

WEST

There's a certain faded glamour to parts of west London. Notting Hill's notorious Portobello Market attracts thousands of visitors each weekend, but the area is most enjoyable during the week, with chic boutiques, restaurants, and pastel-coloured town houses sitting alongside the still-edgy cool of nearby Golborne Road.

The picturesque Serpentine Lake divides Hyde Park and Kensington Gardens, the latter surrounding Kensington Palace, Princess Diana's former residence. On the other side of the park is South Kensington, home to the Natural History, Science, and Victoria & Albert Museums. And while Chelsea had its shining moment in the '60s, today the King's Road is a shopping mecca for well-heeled mothers and daughters. Spend a morning in the Saatchi Gallery, with its frequently updated exhibits and an excellent gift shop, then head farther west to tranquil Brompton Cemetery, where wildlife grows abundantly around the headstones and impressive mausoleums.

The award-winning Queen's Park farmers' market takes place every Sunday on the playground of Salusbury Road Primary School. With everything from organic produce and cheese to fresh fish and flowers, it's a great spot to catch up with friends before decamping to a family-friendly pub nearby.

The Royal Botanic Gardens at Kew is a veritable oasis in the southwest suburbs of the city. Impossible to see it all in a day, gift yourself with a yearly pass and watch the gardens change with the seasons. Highlights include the incredible Victorian glass houses, the Treetop Walkway, the Pagoda, and the mighty redwoods.

119

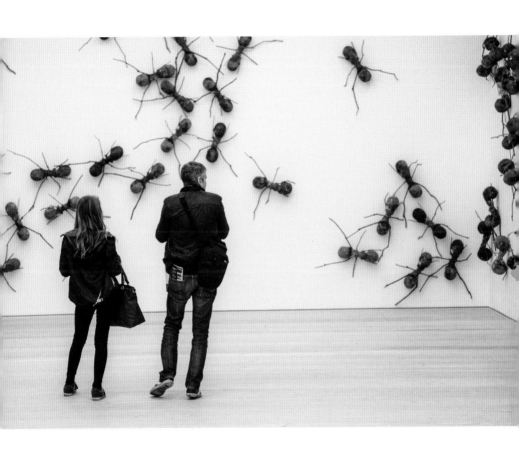

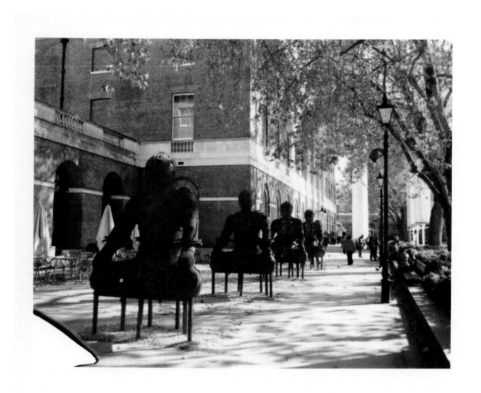

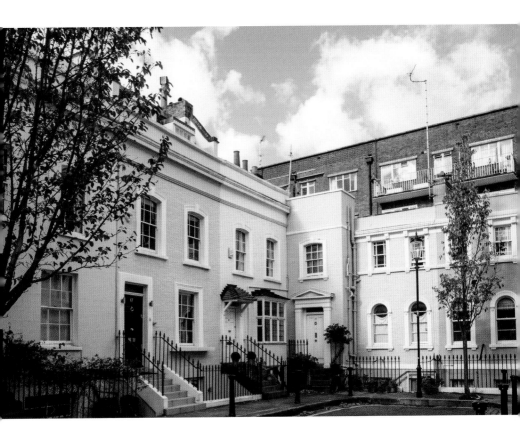

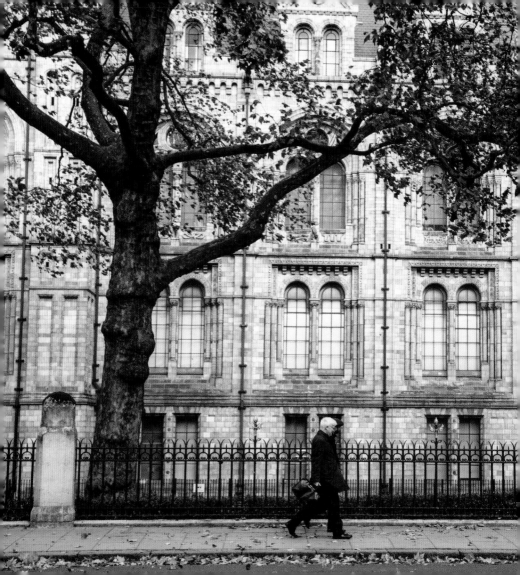

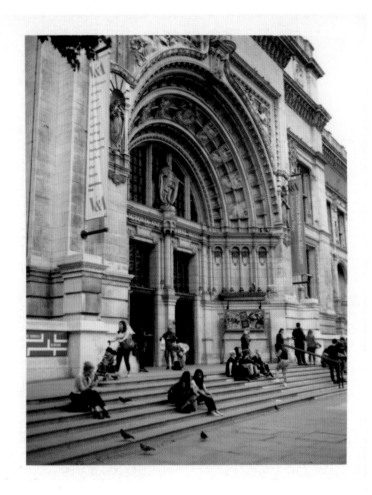

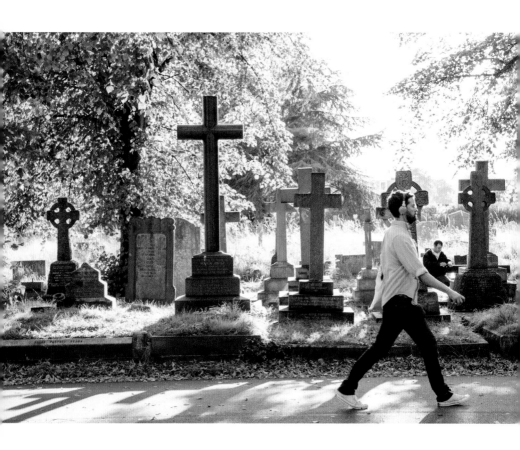

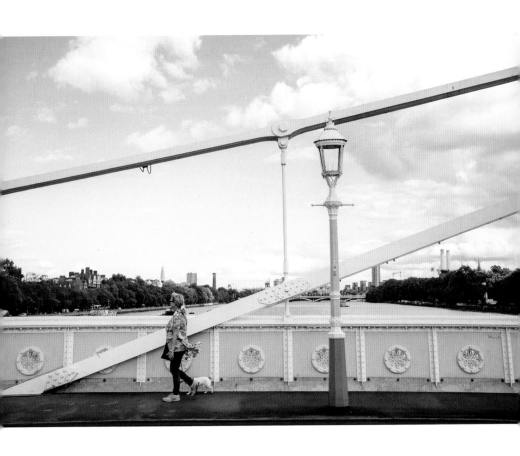

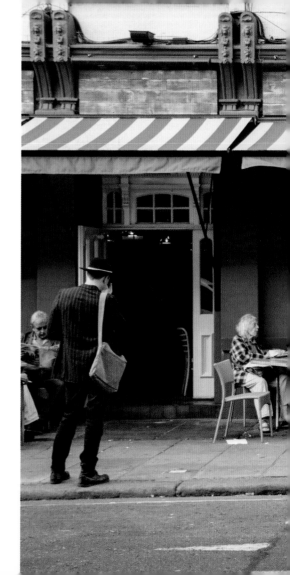

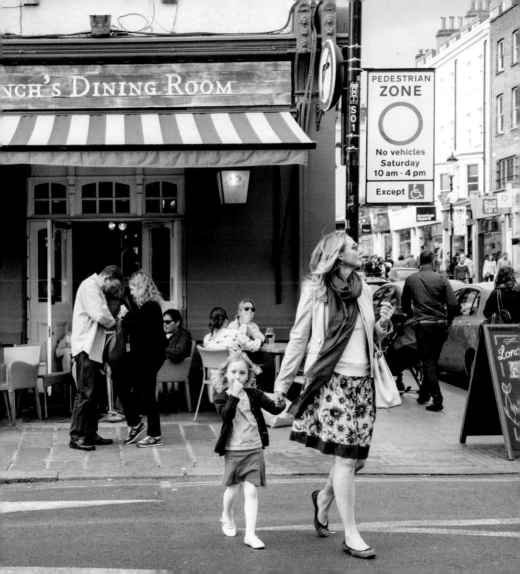

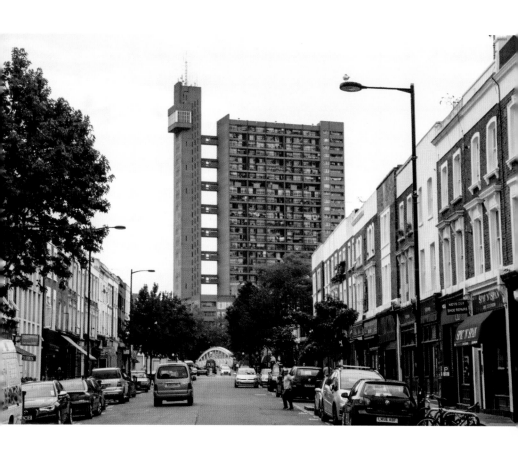

131

133

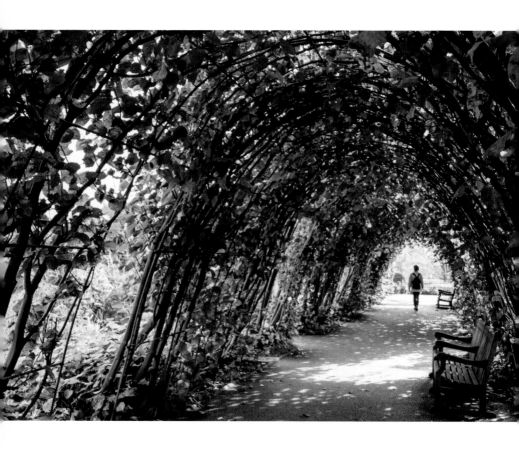

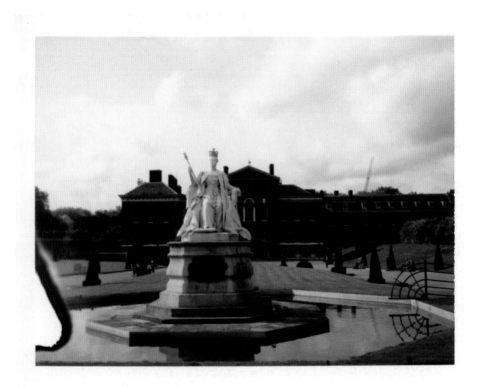

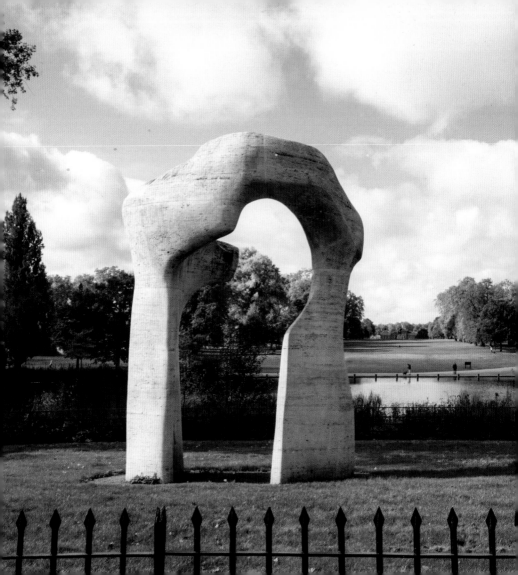

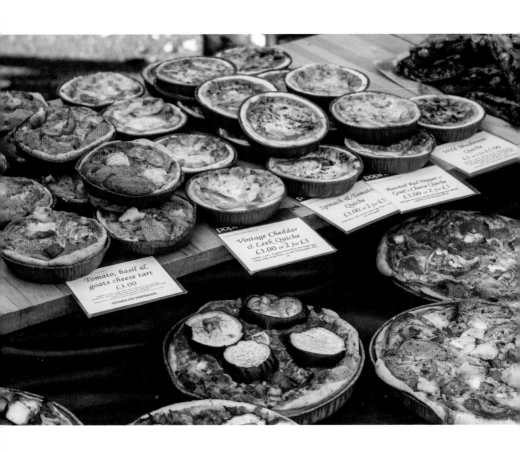

Tomato, basil &
goats cheese tart
£3.00

SUITABLE FOR VEGETARIANS

Vintage Cheddar
& Leek Quiche
£3.00 or 2 for £5

Spinach & Tomato
Quiche
£3.00 or 2 for £5

Roasted Red Pepper &
Goat's Cheese Quiche
£3.00 or 2 for £5

Wild Mushroom
Quiche
£3.00 or 2 for £3.00

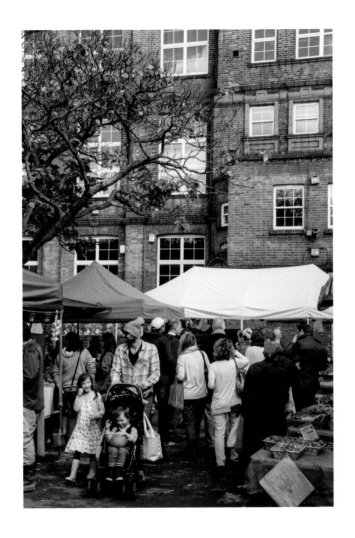

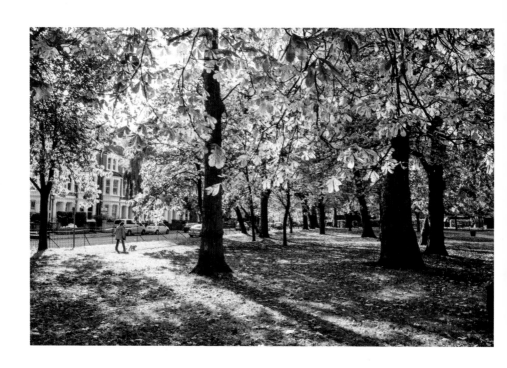

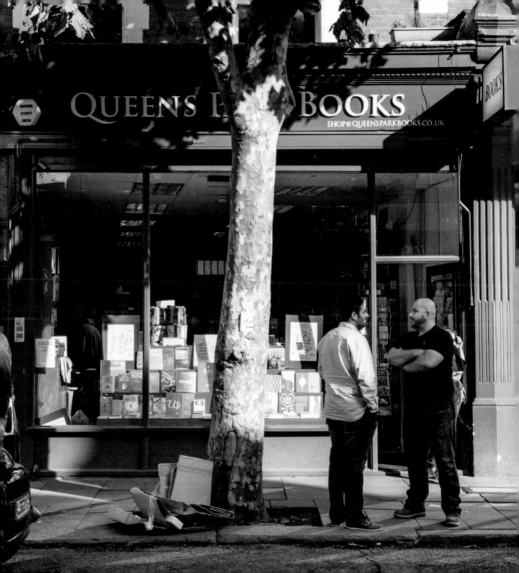

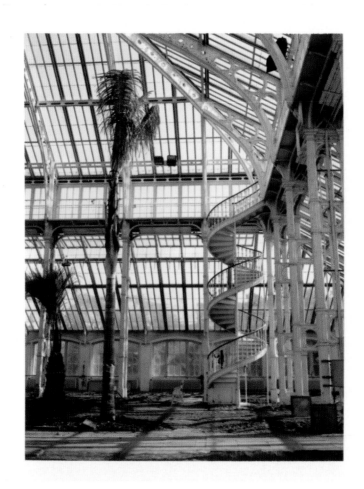

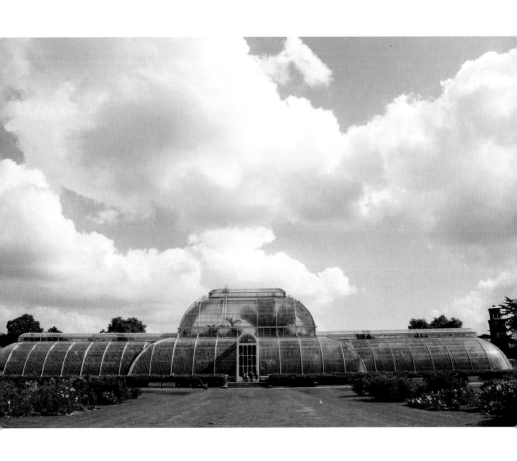

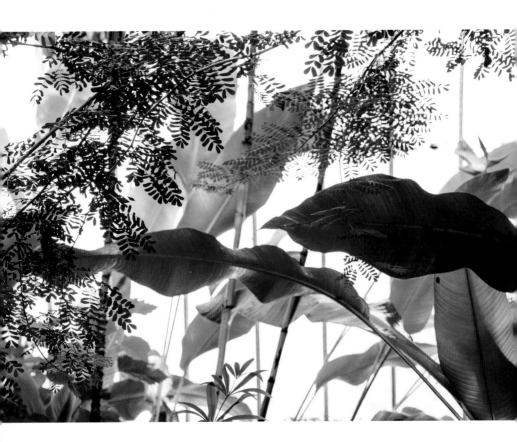

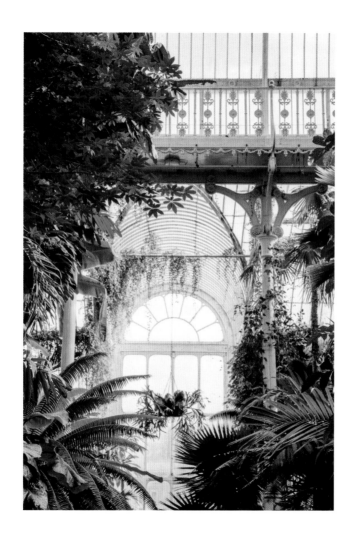

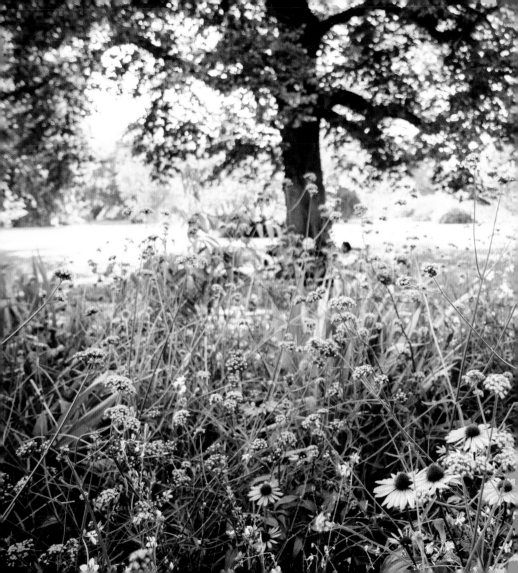

CENTRAL

: ANNO: DECIMO: EDWARDI: SEPTIM
: VICTORIÆ: REGI

Central London is jam-packed with landmarks, all much closer to each other than the Underground map would suggest. Many of London's most popular attractions can be found along the bustling Southbank, including the London Eye, Southbank Centre, Tate Modern, and Globe Theatre. Head farther along for the Design Museum and explore the converted warehouses lining Shad Thames. Keep walking 'til you reach the riverside Mayflower pub then enjoy a drink while imagining the Pilgrims setting sail in 1620.

Trafalgar Square provides endless opportunities for people-watching outside the National Gallery, and at some point everyone takes a walk down the Mall to see Buckingham Palace. Similarly, Westminster has enough big-ticket items to be checked off a to-see list—the policemen outside the Houses of Parliament are surprisingly good-natured.

The West End is for playing, with high street and designer labels along Regent, Oxford, and Bond streets, late-night bars and eateries in Soho, and grand old theatres along Shaftesbury Avenue. Covent Garden and Carnaby Street are firmly established shopping havens while Chinatown is small but mighty, focussed in and around Gerrard Street.

Bookish Bloomsbury lies between Euston Road and Holborn and is filled with garden squares and famous literary addresses. The first national public museum in the world, the

British Museum holds a staggering eight million objects, including the Rosetta Stone, while nearby Lamb's Conduit Street is home to Persephone Books, a small publishing house championing forgotten women authors.

The Barbican Centre and surrounding housing estate are powerful examples of Brutalist architecture. It's a surprisingly peaceful oasis and just a short walk from the Museum of London. Those in the know head to Bermondsey's Maltby Street market at weekends to sample foodie delights from traders who've moved on from nearby Borough Market (which is definitely worth a visit during the week).

Of all the skyscrapers that have appeared in the last decade or so, none is more loved than Norman Foster's 30 St Mary Axe, or The Gherkin, as it's informally known. The Lloyd's Building on Lime Street is even more impressive when viewed from the ground, and for the best view of the city head to the top of the Shard over at London Bridge. You can stay on the viewing deck for as long as you like, so get there before sunset to enjoy a spectacle that never gets old.

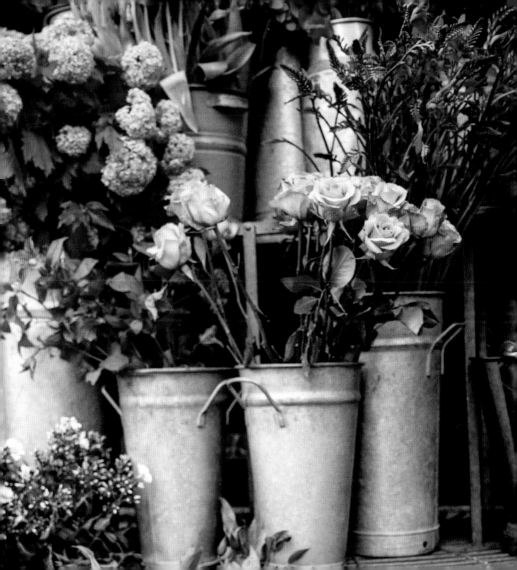

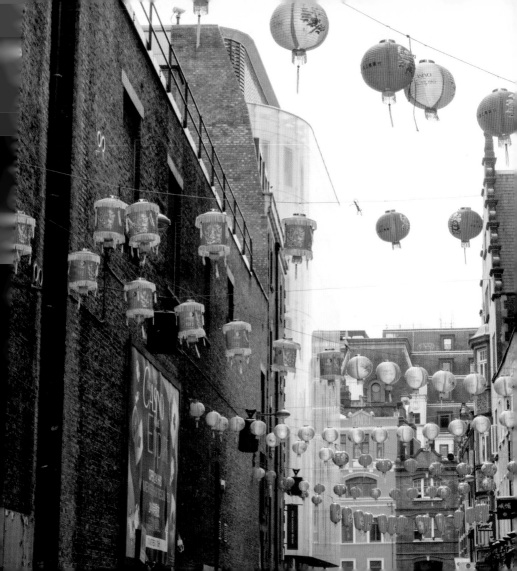

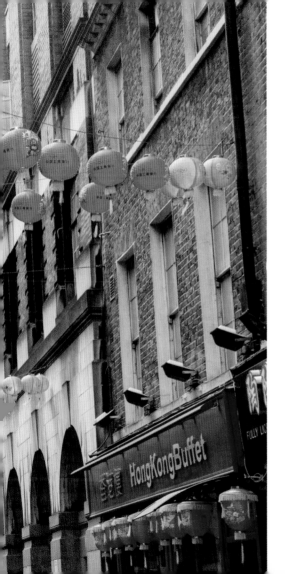

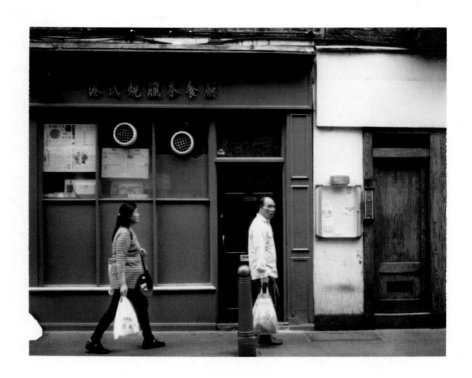

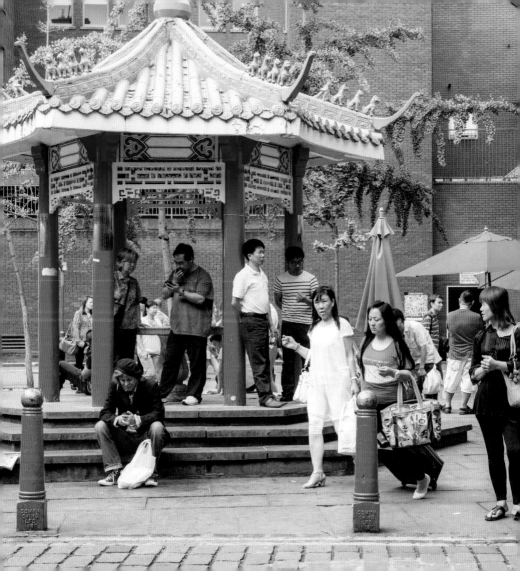

R H SMITH & SONS

QUALITY AND INNOVATION SINCE 1894

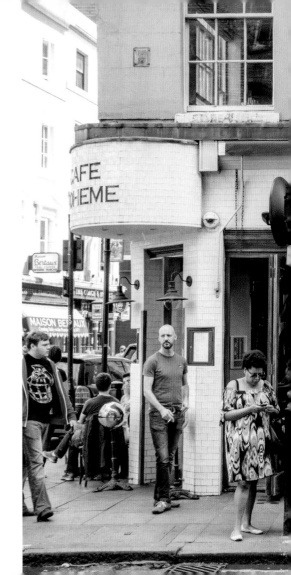

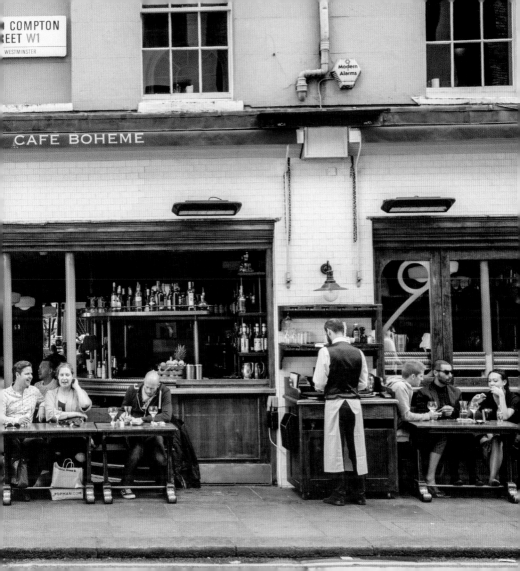

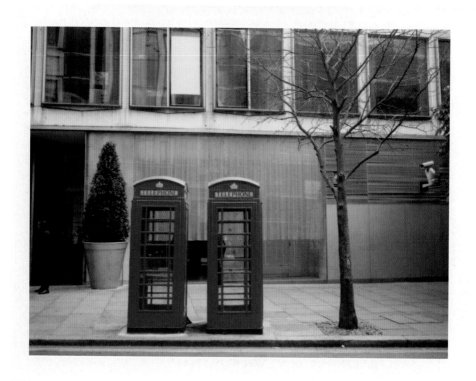

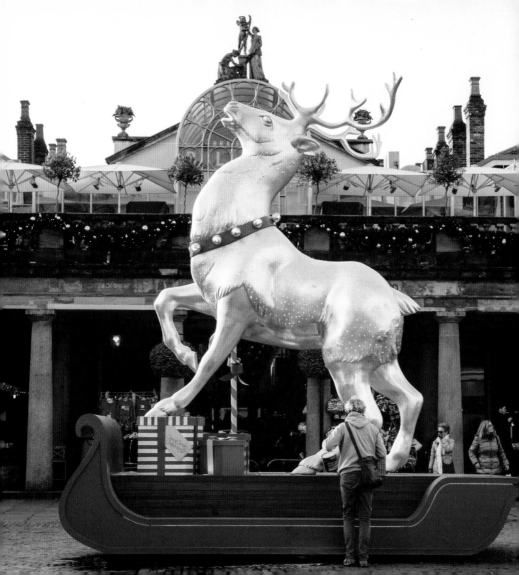

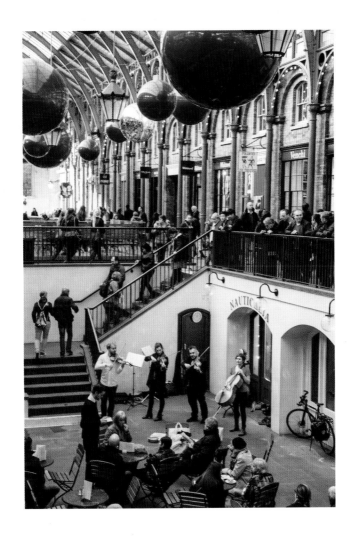

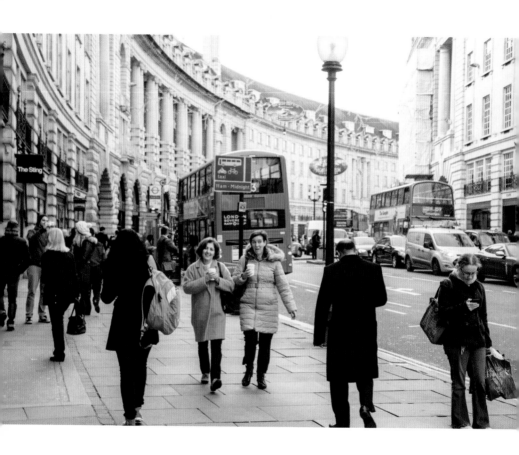

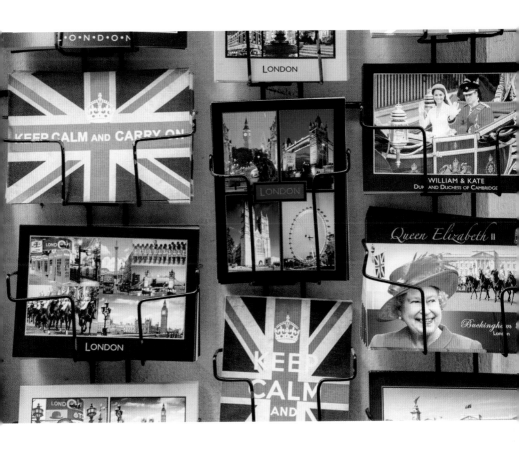

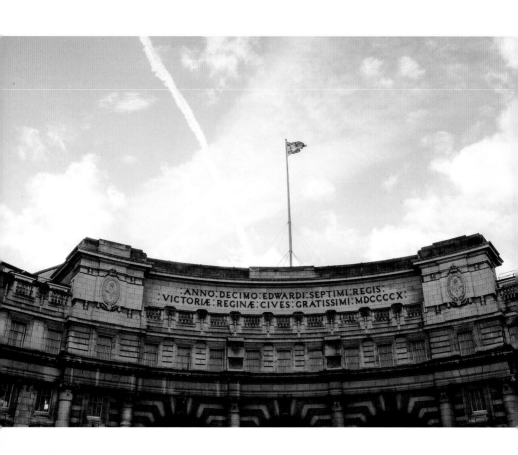

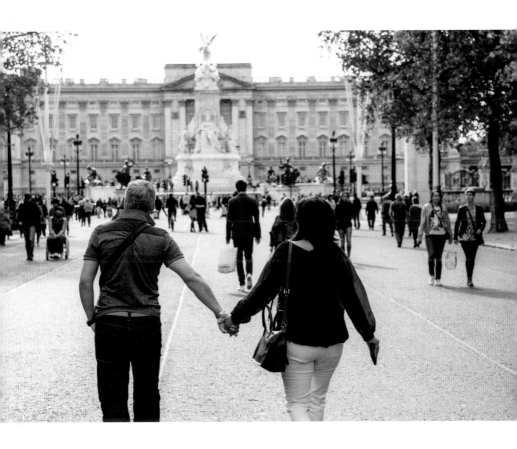

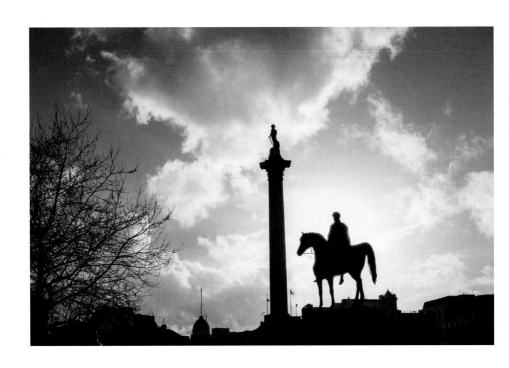

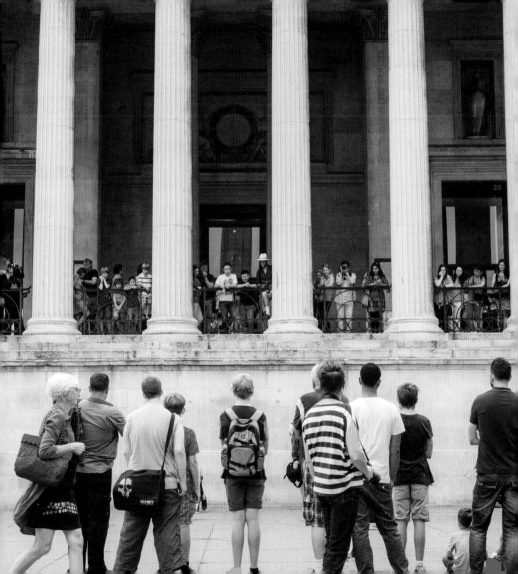

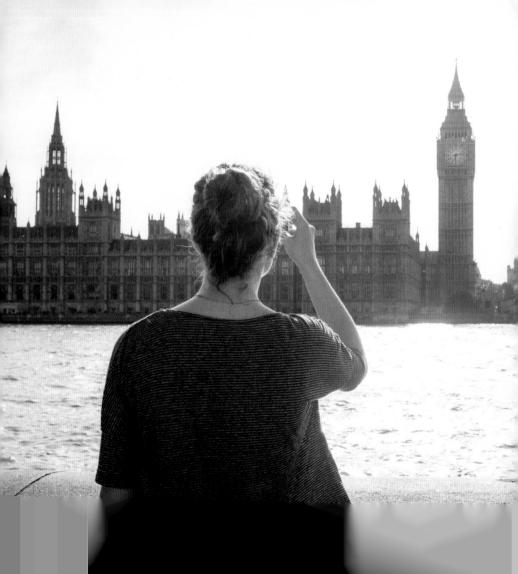

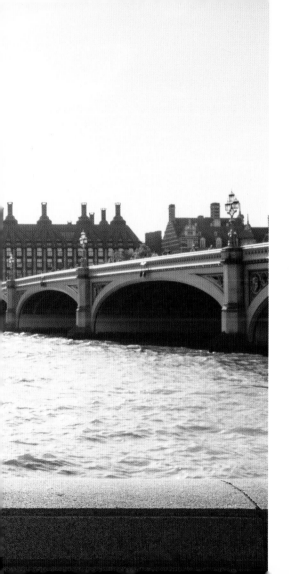

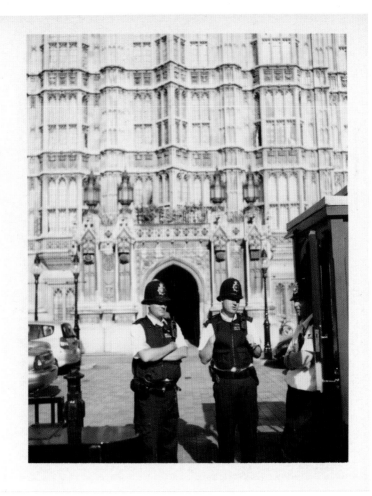

174

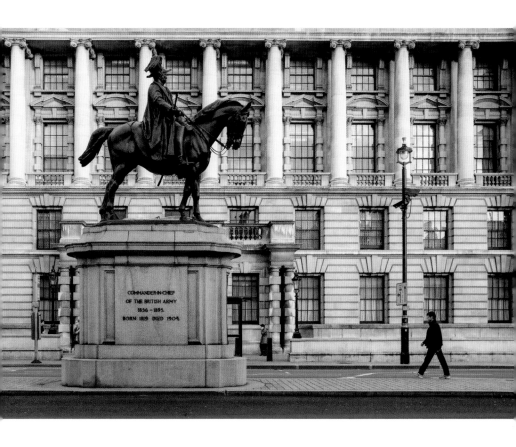

COMMANDER-IN-CHIEF
OF THE BRITISH ARMY
1856 - 1895.
BORN 1819 DIED 1904.

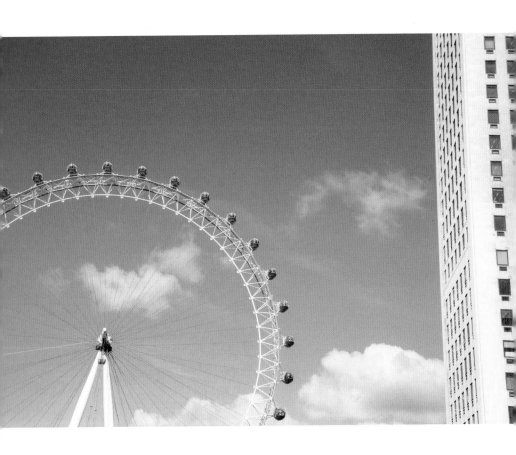

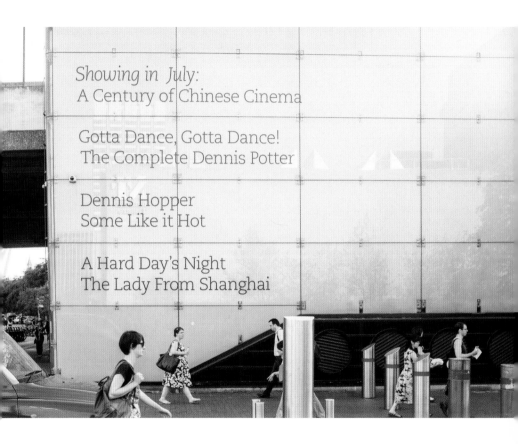

Showing in July:
A Century of Chinese Cinema

Gotta Dance, Gotta Dance!
The Complete Dennis Potter

Dennis Hopper
Some Like it Hot

A Hard Day's Night
The Lady From Shanghai

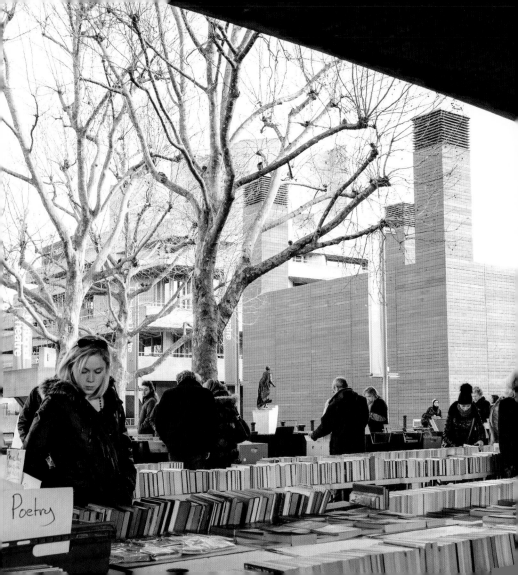

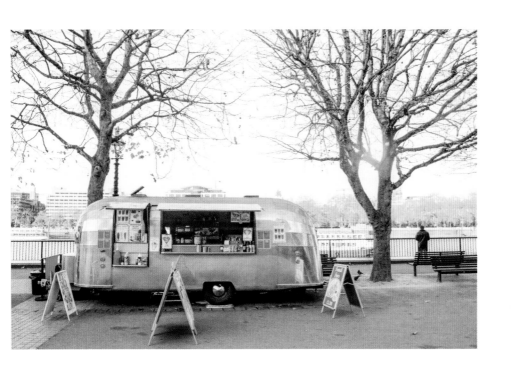

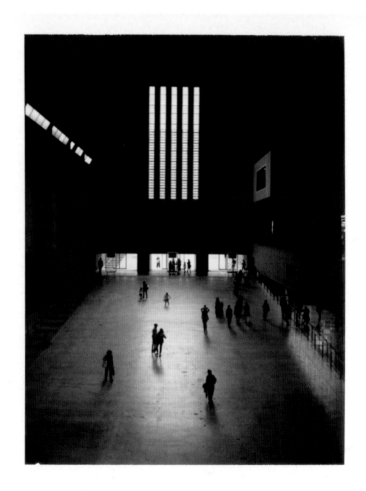

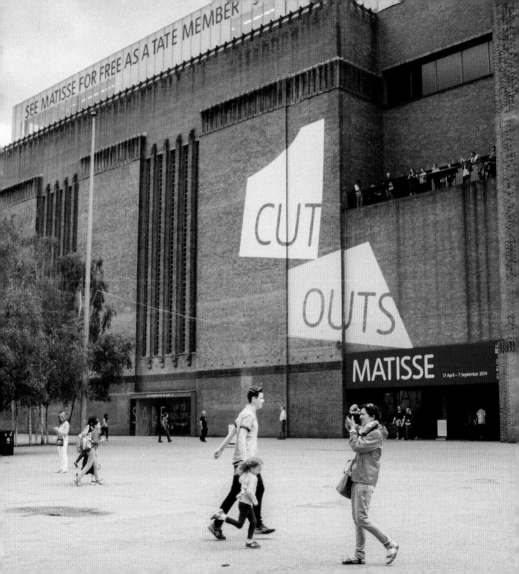

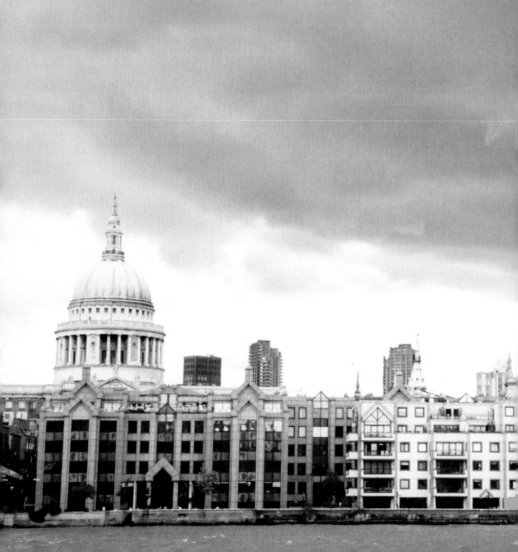

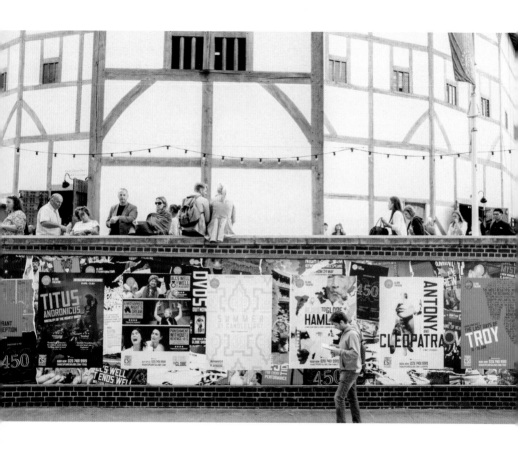

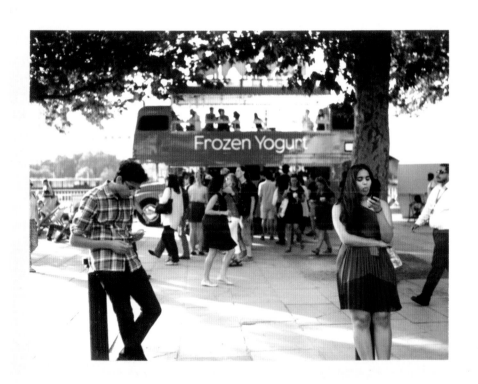

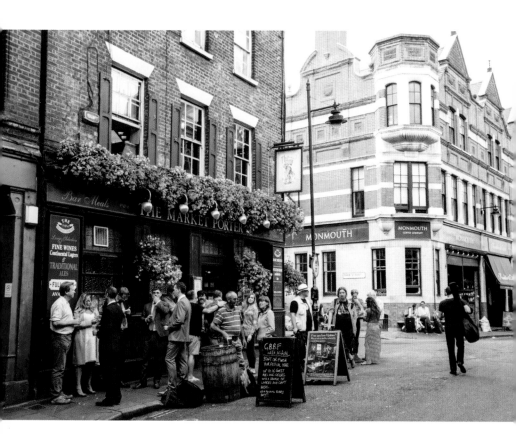

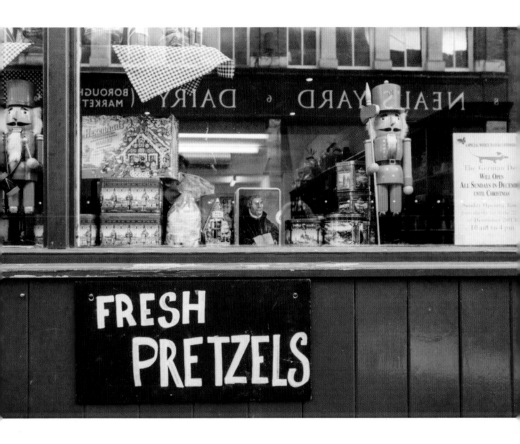

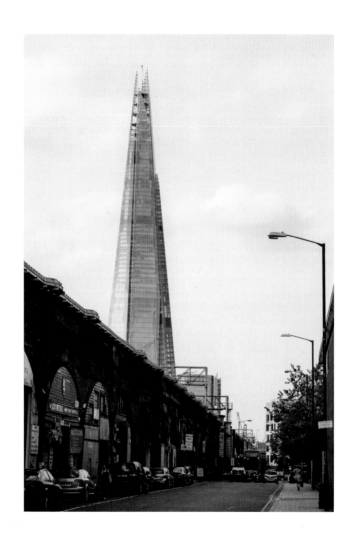

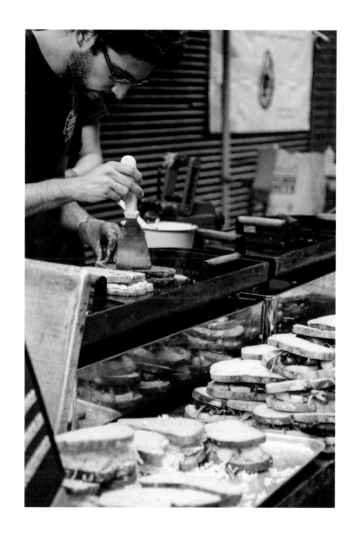

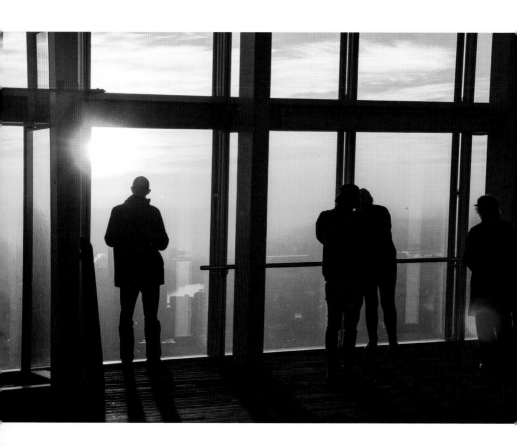

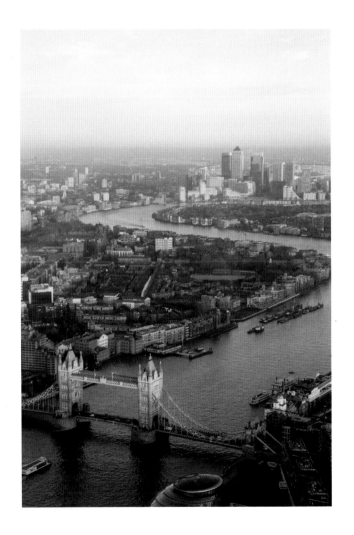

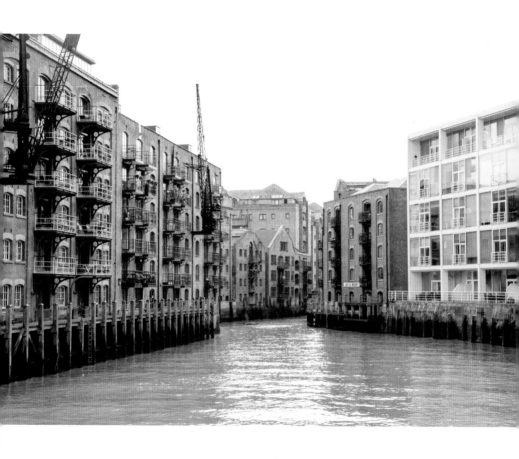

SOMEDAY
THE OTHER
MUSEUMS
WILL BE
SHOWING
THIS STUFF

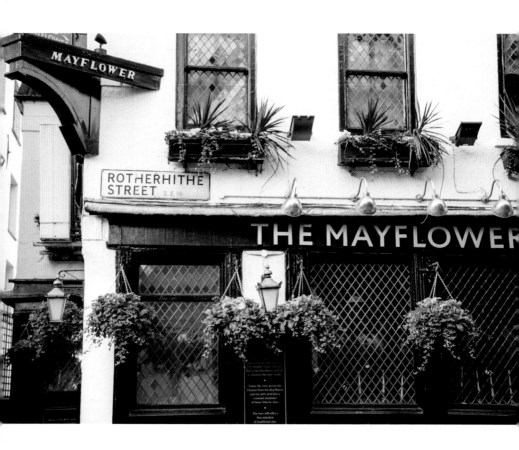

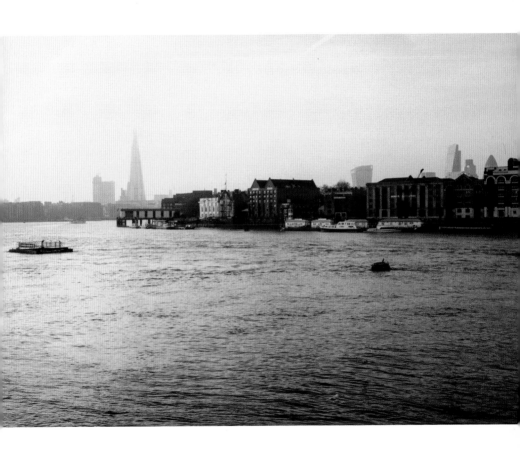

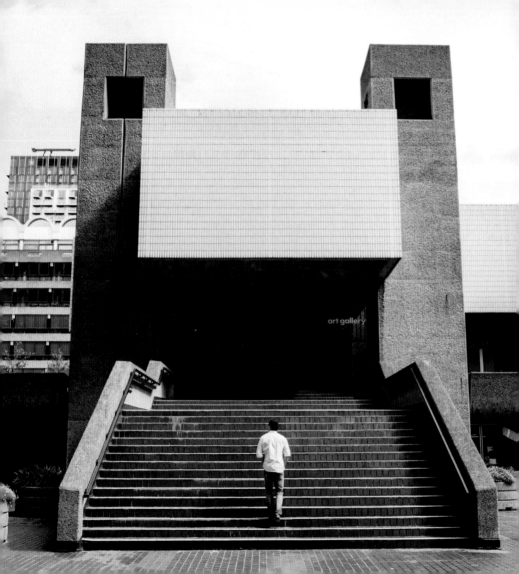

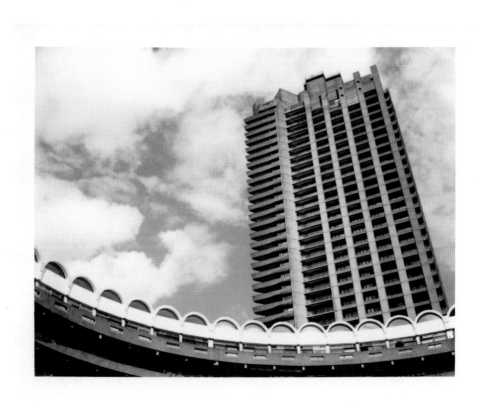

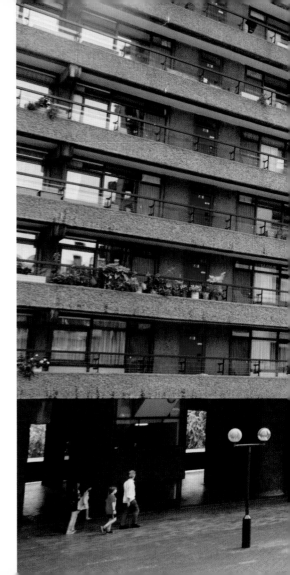

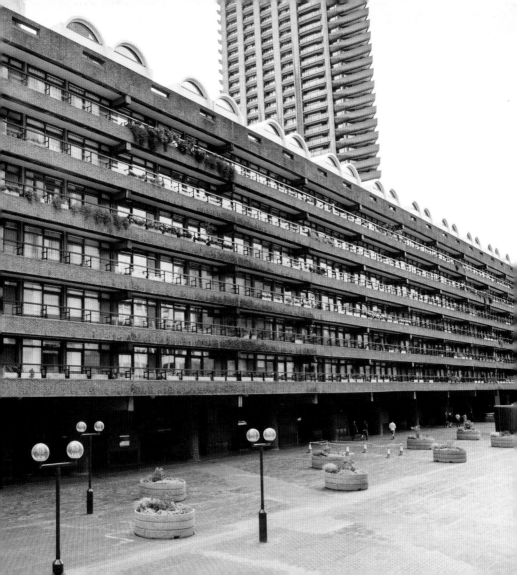

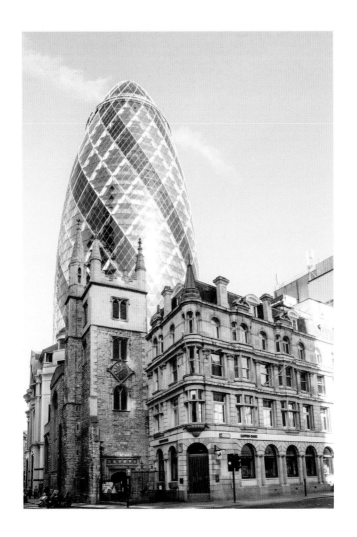

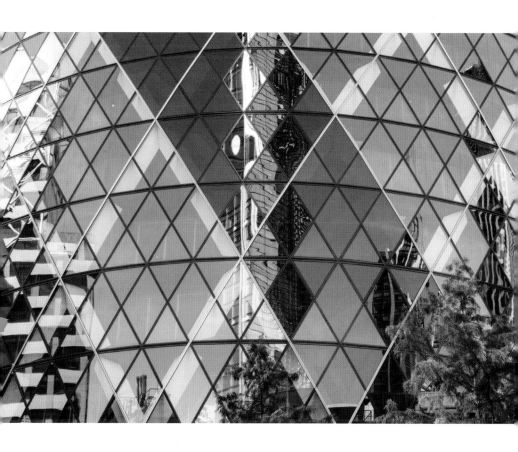

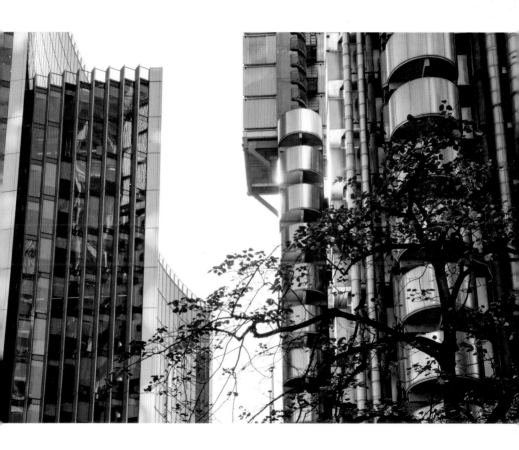

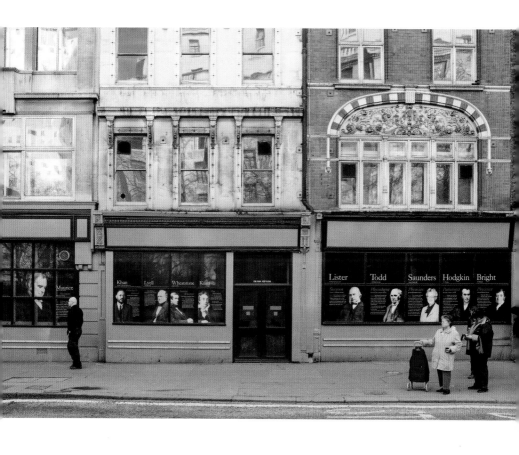

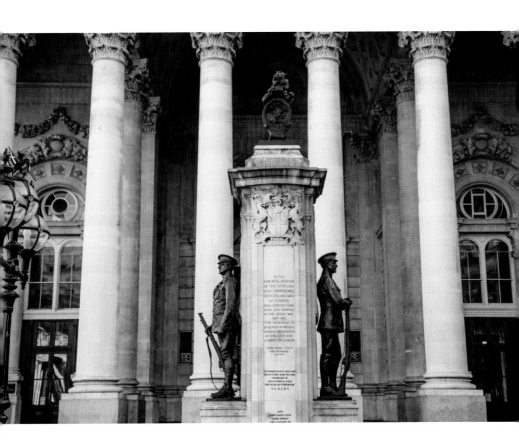

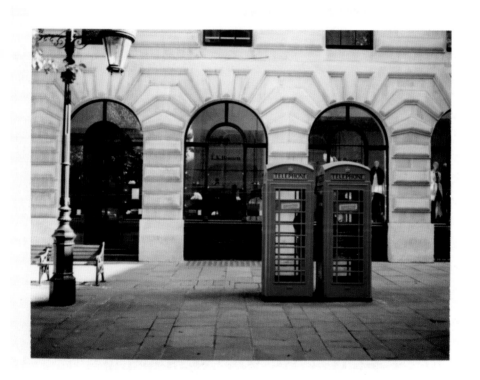

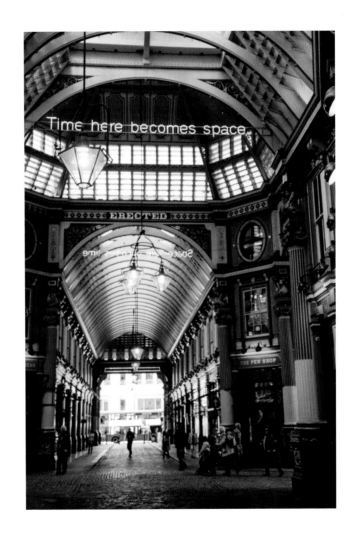

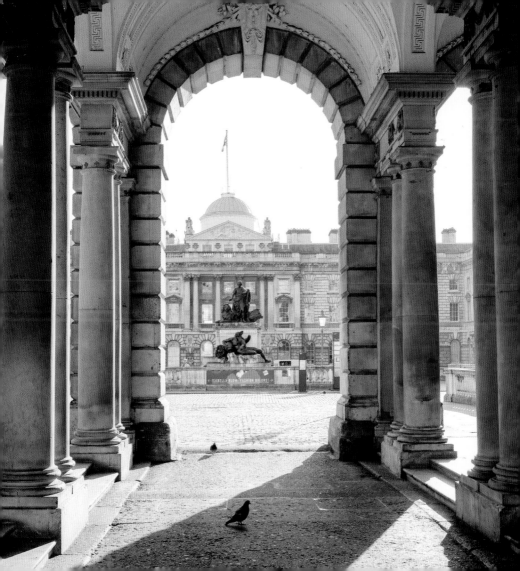

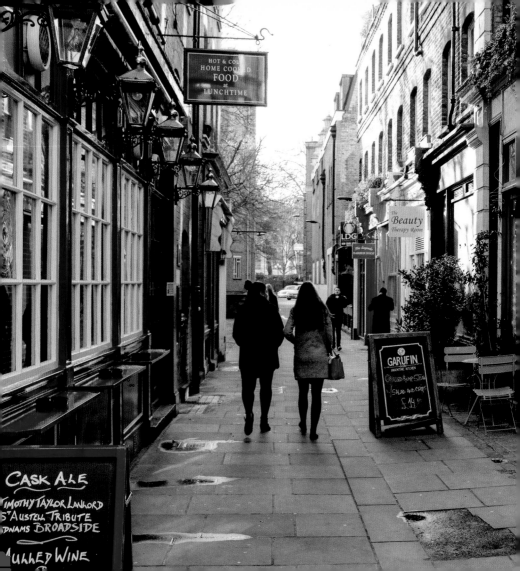

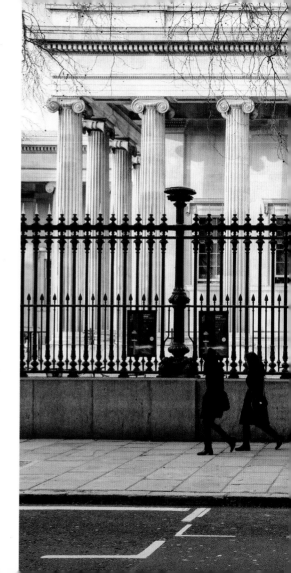

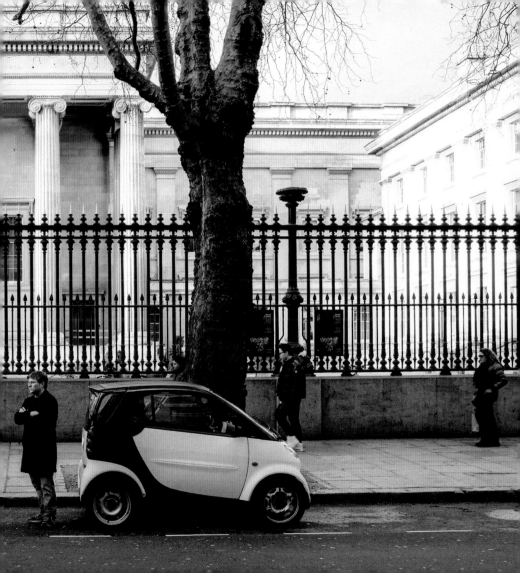

LOCATIONS
NORTH

SOUTH

EAST

WEST

CENTRAL

KEY	⊖ UNDERGROUND	⊖ OVERGROUND	⊖ DLR

Library of Congress Cataloging-in-Publication Data:

Conway, Susannah, author.

Londontown / by Susannah Conway ; foreword by Helen Storey MBE.

pages cm

ISBN 978-1-4521-3726-1 (alk. paper)

1. London (England)—Pictorial works.
2. London (England)—Description and travel. I. Title.

DA684.C73 2016

942.10022'2—dc23

2015020002

Manufactured in China

Design by Brooke Johnson

Typeset in FIN and Mercury Text G2

10 9 8 7 6 5 4 3 2 1

Chronicle Books LLC
680 Second Street
San Francisco, CA 94107
www.chroniclebooks.com